More *Messy* PEOPLE

Praise for More Messy People

Jennifer has mastered the craft of creating fearless and transformative resources. Whether used for individual, small group or all-church study, *More Messy People* serves as a powerful reminder of what God can do in the lives of people just like us!

—**Shane L. Bishop**, Senior Pastor, Christ Church, Fairview Heights, Illinois, author of *That's Good News* and the *The Ping Life*

Well into my sixth decade of life, I have learned a truth that Jennifer so beautifully illustrates in *More Messy People*. It's this simple, yet profound truth. "Don't put a period where God puts a comma." Failure is common to our human existence. Whether they result from our family dysfunction or just making bad choices, God has an amazing and supernatural capacity to transform tragedy into triumph. Jen creatively helps us connect the lives of disordered women and men in the Bible to our lives and together discover the God who loves us most and best.

—**Rev. Dr. Jorge Acevedo**, leadership coach, writer, speaker, retired pastor

Available Components:

More Messy People

9781791033460 Print
9781791033477 ePub

More Messy People: Leader Guide

9781791033484 Print
9781791033491 ePub

More Messy People: DVD

9781791033507

Streaming video for *More Messy People* is available at AmplifyMedia.com.

Also Available from Jennifer Cowart:

Messy People

Fierce

Pursued

Thrive

More *Messy* PEOPLE

LIFE LESSONS *from* IMPERFECT BIBLICAL HEROES

a Bible Study by

JENNIFER COWART

Abingdon Women | Nashville

More Messy People

Life Lessons from Imperfect Biblical Heroes

ISBN 978-1-7910-3346-0

Continued on page 206

To my precious kiddos:
Alyssa, Joshua, Andrew, Hannah, and Jordi

Contents

About the Author

Jennifer Cowart is the executive and teaching pastor at Harvest Church in Warner Robins, Georgia, which she and her husband, Jim, began in 2001. With degrees in Christian education, counseling, and business, Jen oversees a wide variety of ministries and enjoys doing life and ministry with others. As a gifted Bible teacher, Jen brings biblical truth to life through humor, authenticity, and everyday application. She is the author of four women's Bible studies (*Thrive*, *Pursued*, *Fierce*, and *Messy People*) and several small group studies coauthored with her husband, Jim, including *The One*, *Grounded in Prayer*, and *Living the Five*. They love doing life with their kids, Alyssa, Josh, Andrew, Hannah, and the newest addition, their grandson, Jordi.

Follow Jen:

🅾 jimandjennifercowart

🅵 jimandjennifer.cowart

Website: jennifercowart.org or jimandjennifercowart.org
 (check here for event dates and booking information)

Introduction

Hi, friend! Welcome to *More Messy People*!

A few years ago, I began to ponder the amazing reality that God's heroes rarely had neat and tidy lives. They made mistakes. Sometimes big ones! The greats of biblical history had messy stories.

That is relatable to me because my life also is rarely neat and tidy. I have had seasons characterized by great faithfulness, times when I felt very close to the Lord and things seemed to be running smoothly. But at other times in my life, my faith has felt weak and things have seemed they would never be right again. My life is a messy one. I'm guessing yours is too, at times.

As I continued pondering messy lives, I sat down and wrote a Bible study, *Messy People*. In it I examined six flawed but powerful people of Scripture—David, Daniel, Rahab, Josiah, Mary, and the Prodigal Son—and how they allowed God to turn their messes into His masterpieces. Turns out the idea of allowing God to do something positive with our messes resonated with many people—so much so that here I sit again pondering and writing another study, *More Messy People*.

In this study we will dig into the lives of six more biblical heroes—ordinary people who led extraordinary lives because they turned their messes over to God and found that their faithfulness in the hands of the Almighty could bring some magnificent results! Together we will explore the lives of two sisters, Rachel and Leah, along with Moses and Elijah from the Old Testament. Then we will move into the New Testament and explore another set of sisters, Martha and Mary, along with the great leaders Peter and Paul. Each of their stories will help

us see that God chooses to use imperfect people to do incredible things when we turn to Him with our doubts and troubles.

As you move through this study, I hope you will develop the habit of carving out time regularly to be with Jesus. There are five devotional lessons for each week. Give yourself the gift of at least fifteen minutes five times a week just to be still and focus on God, bringing your authentic self before him—messes and all. My hope for you is that at the end of this study you will feel closer to God and more at peace than ever before!

Each day's devotional lesson follows the same format:

Settle: The Scriptures tell us that Jesus often withdrew to a quiet place just to be with the Father. If Jesus needed these moments of solitude and refreshing, then how much more must we need them! So, I invite you to start each devotional lesson with a few moments to intentionally calm your mind and heart and turn your attention toward being in the presence of God.

Focus: Next, focus your mind on God's Word, reading several key verses from the main story for the day, along with any supplemental Scriptures. As you spend time with these Scriptures, ask God to give you new insights and practical ways to apply His word in your life. It's my hope that the passages will leap from the page in relevant and engaging ways. As I read from God's Word, I often ask the question, *So, what?* Although this phrase can be uttered with sass, that is not my intent here. It's a sincere question! *So, what do I do with this, Lord? What do I need to learn, do, repent of, avoid, confess, or watch out for?* Asking *So, what?* is a practical way to approach the Bible and make it immediately relevant.

Reflect: Now get ready to dig into the Bible. This is the heart of the devotional lesson. I'll relate a story to get you engaged, and then it's your turn. We'll move into the meat of the biblical story and see how it enriches *your* life. Each biblical hero we examine will offer us a treasury of lessons, and you'll have the opportunity to do some life application. During this time of reflection, make it personal by looking for how you can apply the timeless truths we glean from the biblical characters' lives in ways that move you closer to Jesus. Space is provided for recording your responses and completing exercises.

Pray: Finally, be still once again and enter into a time of prayer, asking the Holy Spirit to speak new truths of peace and wisdom into your life. Each day I will offer either a prayer or a few prayer suggestions intended to help your time with God be fresh and interesting.

As you begin this journey, set yourself up for a win. Find a quiet spot where you can be still before the Lord, and lay out the supplies you will need each day, such as your Bible, this workbook, and a pen. You also might consider gathering a journal, sketch pad, instrument, or other tools for creative expression if you're so inclined. If you're musical, you may want to begin each devotional lesson by singing or playing an instrument. If you're artistic, you may want to end by sketching or painting. Perhaps your gift is the written word; then journal what God is speaking to you. You also may want to incorporate praise and worship music as well as dance, stretching, or other physical activity into your devotional study time. Be creative! Think outside your usual practices and try something new.

You have the plan: this workbook of devotional lessons. Now set aside the place and the tools and get ready to create a pattern of sacred meeting between you and your heavenly Father!

Life is filled with messy moments. Sometimes those messy moments become messy seasons. If you're in one now, I hope this study will bring you encouragement and, perhaps, give you some tools for moving forward. Remember, God loves working in the lives of messy people because messy people are all He has to work with! So, as you get started, just put your hand in His and invite Him to turn your messes into His masterpieces!

From one messy person to another, let's do this!

WEEK 1
Leah and Rachel

Overcoming Jealousy

Genesis 25–31; 35; 37

Memory Verse

God decided in advance to adopt us into his own family by bringing us to himself through Jesus Christ. This is what he wanted to do, and it gave him great pleasure.

(Ephesians 1:5 NLT)

DAY 1

Settle

Today begins a six-week journey to discover how very much God loves messy people like you and me! As you begin, stand up and take a few slow, deep breaths and just be still before the Lord. Ask Him to speak to you in new and fresh ways during this time. Now take a few more deep breaths and just sit before Him in silence for a minute or two. Allow whatever troubles may be on your mind to melt away as you give God your full attention.

Focus

Read Genesis 25:27-34 and Genesis 27:1-46.

Jacob said to his father, "I am Esau your firstborn. I have done as you told me. Please sit up and eat some of my game, so that you may give me your blessing."

(Genesis 27:19)

Esau held a grudge against Jacob because of the blessing his father had given him. He said to himself, "The days of mourning for my father are near; then I will kill my brother Jacob."

(Genesis 27:41)

¹⁶Now Laban had two daughters; the name of the older was Leah, and the name of the younger was Rachel. ¹⁷Leah had weak eyes, but Rachel had a lovely figure and was beautiful. ¹⁸Jacob was in love with Rachel and said, "I'll work for you seven years in return for your younger daughter Rachel."

(Genesis 29:16-18)

For we are God's masterpiece. He has created us anew in Christ Jesus, so we can do the good things he planned for us long ago.

(Ephesians 2:10 NLT)

Reflect

Have you ever made a big, stinky mess? I've made many in my life. But one of the biggest was right after starting a new job as a student minister. In my youthful enthusiasm I organized a literal slop fight!

I split the kids into four groups of about fifteen each and gave them a week to fill a garbage can with as much "slop" as they could muster. There were a few rules about what could go in the

cans. Nothing too disgusting and no hard objects allowed. It was basically a composting experiment turned into WrestleMania.

It was epic! The kids dressed in rain gear and goggles and we assembled in the church parking lot with our four full trash cans. On the whistle, we began to fling and laugh and slip. Yup, I said *we*. I got in there too, slinging leftover sloppy joes and cereal right alongside them. It was hysterical. Parents came to watch and cheer on their children.

Was there a winner? I think we all won because we created a great memory together. We laughed and we bonded. And that was exactly what I was hoping for!

When I look back on my ministry, that slop fight is one of the most memorable moments I've ever had. But wow, what a mess! I knew there would be clean up, but I was not prepared for what lay before us that night in the aftermath. We picked up the big stuff, like soggy pizza and week-old bread. But there was so much more. I actually prayed it would rain, hard, before the senior pastor saw it!

Then one of the kids said, "I have an idea. I'll call the fire department. They'll come spray it down." (That kid had connections!) Within a few minutes a fire truck showed up. The power of the fire hose took all of five minutes to completely wash away the mess we had created.

Wouldn't it be great if all of life's messes could be cleaned up that easily?

What's the biggest mess *you've* ever made? I'm not speaking metaphorically. I mean, literally, what is the biggest, stinkiest mess you've ever been responsible for?

What kind of help did you need to clean it up?

Now, let's dig a little deeper. It's part of the human experience to deal with messes. There are literal ones, like soiled diapers and spilled spaghetti sauce. Those are a pain, but with a little attention they are fixable. It's the intangible messes of life that are hard to handle. The messes that affect us spiritually, relationally, and emotionally are the truly tough ones.

Sometimes these messes are just a natural part of doing life, like facing a recession or dealing with sickness. But sometimes our messes result from how others have treated us—or worse, they are a result of our own poor choices. Many of life's messes are the direct result of sin. Sin always creates a mess!

The good news is that God loves messy people!

As we journey together over the next six weeks, we're going to dig into the lives of different people from Scripture, each of whom plays a significant role in the biblical narrative. But as we'll soon see, their stories are far from perfect. Personally speaking, that's good news because my story isn't perfect, either. The messiness of their stories isn't so different from my own. For example, they frequently chose their way instead of God's way; they often were scared, selfish, and stubborn, and they experienced discouragement, doubt, and disappointment. I've experienced all those things! I'm guessing you will find yourself reflected in their stories too.

The timeless truths that we can learn from each of these messy people are as applicable today as they were thousands of years ago. So, as we journey together, remember that simply learning their stories is not the only goal. Our primary goal is to take what we learn from them and apply those lessons in our own lives so that we become wiser and, we hope, better reflections of Jesus.

This week we are looking at two sisters, Leah and Rachel. They are Laban's daughters, Jacob's wives, mothers to the tribes of Israel, and baby-making rivals. Let me set the scene for their story.

Jacob, their husband, was the son of Isaac and Rebekah. He was the grandson of Abraham and Sarah and twin brother to Esau. Since birth, Jacob had been a schemer. His name, Jacob, literally means deceiver. Jacob's life was defined in the early years by conflict and competition. His parents played favorites, and that created an atmosphere in which Jacob felt the need to get an upper hand—which he did. True to his name, he swindled his brother out of his birthright and tricked his father into giving him the paternal blessing.

The good news is that God loves messy people!

Read Genesis 25:29-34. How did Jacob scheme to get his brother's birthright?

Now turn to Genesis 26:34–27:41. How did Jacob scheme to take Esau's blessing?

According to verse 41, what was the result of Jacob's scheming?

Read Genesis 27:42-46 and 28:1-5. What plan did Rebekah hatch to save her son? Where did Isaac send Jacob, and what did he instruct Jacob to do there?

Jacob's scheming caused his brother, Esau, to hate him and even want to kill him. So, Jacob fled to live with his mother's brother, Laban—another schemer.

This is where Jacob experienced an ironic twist of events. The deceiver became the deceived. When Jacob first arrived at his uncle's home in Paddan Aram, his plan was to locate his relatives, spend a few months there while Esau cooled off, and find a wife. Then he could be on his way back home. But he met Rachel, and his plan turned to mush. This was the woman he wanted to spend his life with!

Jacob negotiated with Laban and agreed to work seven years in exchange for Rachel's hand in marriage. But, as we read in the biblical account, scheming was part of this family's DNA.

Read Genesis 29:1-30. How did Laban trick Jacob?

Can you imagine how Jacob, the deceiver, felt when he realized he had been deceived at the altar and married Leah instead of his beloved Rachel?

Obviously, we could devote an entire week to the messy person of Jacob, but let's concentrate on Laban's daughters, the sisters who were left to deal with the fallout of this devastating bridal switch up. Imagine their situation. Leah and Rachel had grown up together. Surely, they had giggled and played together as girls. They probably had shared with each other their dreams for the future. But now deception has disrupted those dreams, tearing them apart.

We'll examine Rachel and Leah's lives in greater depth in the coming days. For now, let's marinate in this moment in their story. Their dreams of marriage and family suddenly have become complicated and filled with pain. How might their story relate to your own?

What dreams did you have as a child?

Which of those dreams are you now living out?

Which of those dreams have become complicated or filled with pain?

What messes in your own life do you want to examine as you move through this study?

Life gets messy, but know this: God can take whatever mess you're dealing with and bring something amazing from it! All we have to do is put our trust in Him. Just as the fire truck showed up in time to wash away the slop, God is

ready to come alongside you and help you clean up the messes in your life by turning them into something amazing!

Ephesians 2:10 (NLT) says, "For we are God's masterpiece. He has created us anew in Christ Jesus, so we can do the good things he planned for us long ago."

Let's personalize this passage:

You, _____ (write your name here),

are God's masterpiece. He created you anew in Christ, so that you,

_____ (write your name here),

can do the things He planned for you (yes, you!) long ago.

God sees you. He loves you. And He calls you His masterpiece. Rest in that, my friend!

Pray

- Thank God for His endless unconditional love.
- Ask Him to give you new insights into who He is and who He is calling you to be as you begin this study.
- Seek His forgiveness for the messes you've created in your life and the lives of others.

DAY 2

Settle

Set a timer on your phone for two minutes. Then just sit still before the Lord, laying aside all distractions of the day. It's usually in the still moments that we are able to hear God speak.

Focus

²²So Laban brought together all the people of the place and gave a feast. ²³But when evening came, he took his daughter Leah and brought her to Jacob, and Jacob made love to her. ²⁴And Laban gave his servant Zilpah to his daughter as her attendant.

²⁵When morning came, there was Leah! So Jacob said to Laban, "What is this you have done to me? I served you for Rachel, didn't I? Why have you deceived me?"

²⁶Laban replied, "It is not our custom here to give the younger daughter in marriage before the older one. ²⁷Finish this daughter's bridal week; then we will give you the younger one also, in return for another seven years of work."

²⁸And Jacob did so. He finished the week with Leah, and then Laban gave him his daughter Rachel to be his wife. ²⁹Laban gave his servant Bilhah to his daughter Rachel as her attendant. ³⁰Jacob made love to Rachel also, and his love for Rachel was greater than his love for Leah. And he worked for Laban another seven years.

(Genesis 29:22-30)

You are a chosen people, a royal priesthood, a holy nation, God's special possession.

(1 Peter 2:9)

Reflect

A young couple who were expecting their first child recently asked me who they could study in the Bible that really got it right as parents. They wanted to study a healthy, functional family from scripture that they could

use as role models. What a sweet question. This couple is precious. They want to do things in a way that honors God. But, who could I refer them to in Scripture?

Adam and Eve? Well, not with the whole fruit in the garden and Cain and Abel situations. Maybe Abraham and Sarah? Nope, remember Hagar? Isaac and Rebekah? No, they played favorites, which caused all kinds of drama. David came to mind. He seemed to love his family, but he made a mess of raising his children. I had to admit, the plain truth of it is that there is no perfect family to recommend in the Bible—or anywhere!

We are all messy people, even in the Bible. So, I pointed this couple to the principles of God instead of concentrating on just one particular family. I suggested they immerse themselves in God's Word and then apply what they learn to how they live and how they are crafting their home.

The Bible doesn't tell us how to behave in every given situation, but it does tell us what kind of people we are to become. And out of our character, which should grow to be more and more like Christ, comes our actions. So, I suggested they study passages like these:

The Bible doesn't tell us how to behave in every given situation, but it does tell us what kind of people we are to become.

⁵Love the LORD your God with all your heart and with all your soul and with all your strength. ⁶These commandments that I give you today are to be on your hearts. ⁷Impress them on your children. Talk about them when you sit at home and when you walk along the road, when you lie down and when you get up.

(Deuteronomy 6:5-7)

Seek the Kingdom of God above all else, and live righteously, and he will give you everything you need.

(Matthew 6:33 NLT)

¹²Therefore, as God's chosen people, holy and dearly loved, clothe yourselves with compassion, kindness, humility, gentleness and patience. ¹³Bear with each other and forgive one another if any of you has a grievance against someone. Forgive as the Lord forgave you. ¹⁴And over all these virtues put on love, which binds them all together in perfect unity.

(Colossians 3:12-14)

Then, I had two more suggestions for this young couple.

1. Find some Christian mentors—people who have raised incredible humans—and ask them great questions. Be a learner!
2. Know in advance you won't always get it right. Neither will your child. We're all messy. The good news is God loves us even in our messiness.

How do the Scripture verses on the previous page speak to you? What insights or inspiration do they offer you regarding the messes you identified yesterday on page 17?

Who are—or possibly could become—some Christian mentors in your life? Write their names below, along with some questions you would like to ask them.

On a scale of 1-10, with 1 being very easy and 10 being very difficult, circle how easy or difficult it is for you to believe that God loves you even in your messiness. Explain your answer in the space below.

1 2 3 4 5 6 7 8 9 10

As we look at Rachel and Leah this week, we will immediately see that they come from a long line of family dysfunction. Their mother-in-law, Rebekah, their father, Laban, and their shared husband, Jacob, were all deceivers.

Here's a quick recap of their most notable deceptions. Jacob conned his brother out of his birthright, Rebekah helped Jacob deceive Isaac out of his blessing, and Laban tricked his son-in-law with a bridal altar switch that unleashed decades of drama. Truly this family knew all about dysfunction!

What do we observe from this family about the nature or pattern of family dysfunction?

As a result of the wedding day switcheroo, Leah and Rachel ended up sister-wives. Now, before we go further, let's address the issue of multiple wives, which we see often in the Old Testament. This was not an uncommon practice in ancient cultures and is still practiced today in some places. Solomon, David, Abraham, and, of course, Jacob are prime examples of biblical men who had many wives and sexual partners. It may leave you asking, as it has me in the past, "*So, is that okay?*"

This is where Scripture is being *descriptive*, meaning it describes what happened, but not necessarily *prescriptive*, meaning this is how God wants relationships to function. In fact, if you look more closely at polygamous relationships in Scripture, you'll notice that whenever there were more than two people involved in the marital relationship, it was messy. Jesus described the covenant of marriage this way in Matthew 19:5-6, "'a man will leave his father and mother and be united to his wife, and the two will become one flesh'...So they are no longer two, but one flesh. Therefore what God has joined together, let no one separate."

As we take a look at what happened when there was more than one wife or sexual relationship in a marriage, it was a disaster—just ask Sarah or Rachel. Today we see the same kind of disastrous effects in marriage when there is infidelity. Although having multiple wives was a cultural norm then, that doesn't mean it was a good idea.

What are some cultural practices we see today that could be called into question by Scripture?

Jacob intended to marry Rachel. Upon first meeting her, he was quite taken by her.

Look again at Genesis 29:17 (page 13). How does this verse describe Rachel? What drew Jacob's attention?

How does this verse describe Leah?

We're told that Rachel "had a lovely figure and was beautiful." Leah, on the other hand, is described simply as having "weak eyes" (Genesis 29:17). This was not a compliment. Their father, Laban, wanted to ensure that his older—and apparently less desirable—daughter was married first according to custom. So, he deceived Jacob and secured his son-in-law's labor for another seven years.

I have always wondered about what was happening behind the scenes here. Where was Rachel? Was she locked up and not allowed to say, "Hey, that's not me"? And what about Laban's wife? Was she complicit? Then, there was Leah. What was she thinking? But I have the most questions for Jacob. Dude, did you not even notice that you married and then slept with the wrong girl? The only thing I can figure is that there must have been alcohol involved in a mistake of this magnitude!

We can only speculate as to the answers. But here's what we can be fairly sure of: nobody but Laban was happy at the end of the wedding festivities. And nobody, including Laban, was happy at how the whole thing eventually

played out. The conflict, competition, and contempt that were created by this double union not only affected Leah and Rachel but also deeply impacted their children.

Turn to Genesis 37:1-36. What did ten of Jacob's sons do to Rachel's son Joseph? What clues do you find in the passage that might help to explain (not justify) their actions?

The brothers threw Joseph into a well, intending to kill him. But later they decided to sell him to some traveling merchants, who took him to Egypt. As despicable as that was, we find some clues for their disdain for their younger brother earlier in the chapter. First of all, we see that Joseph was a tattletale, giving his father a bad report on his brothers after tending flocks with them. Then we're told that Joseph was their father's favorite, made evident by the ornate robe their father had made for Joseph. The brothers "hated him and could not speak a kind word to him" (v. 4). Finally, Joseph told his brothers about a dream he had in which he ruled over them, and "they hated him all the more" (v. 5).

It's important to linger over the dysfunction and messiness of this family because this is no ordinary family. This is Jacob's family. Jacob, who is later renamed Israel. Jacob, who has twelve sons through his wives, Rachel and Leah, and their maidservants, Zilpah and Bilhah. And it is these sons who become the twelve tribes of Israel and give birth to a nation, Israel. It is from this messy bloodline that we meet biblical greats such as Moses, Deborah, Elijah, Esther, David, Solomon, Elisha, Joseph, and eventually Jesus Himself. Although this is a dysfunctional family, God brings greatness through them. And that, again, is great news for us!

What family messes have you had to deal with? How has family dysfunction affected *you*?

How can you move beyond the mess and dysfunction to a healthy way of living? What are you doing to try and prevent the next generation from repeating the same cycles?

If God can choose, bless, and use a family with as much baggage as Jacob's family, then that gives me hope! I have baggage too. And because you are human, I know you do too. But friend, I have very good news for you. First Peter 2:9 says, "You are a chosen people, a royal priesthood, a holy nation, God's special possession." Isn't that a sweet verse? You are God's special possession. You are chosen.

God chooses and uses really messy people just like you and me. Actually, He has to, because we're all He's got to work with. We're all messy. What we have to do is choose to let God redeem our messiness and use us to bring Him glory.

Pray

Lord, I want to be a godly example to those around me. Help me move past the hurts and habits of my past in order to live my best life. I need your help, Lord. Please give me wisdom and a desire to know your Word so that I can live into it. Amen.

> **God chooses and uses really messy people just like you and me.**

DAY 3

Settle

Try starting this time with the Lord by listening to a favorite song that brings you a sense of peace and closeness to God.

Focus

³¹When the LORD saw that Leah was not loved, he enabled her to conceive, but Rachel remained childless. ³²Leah became pregnant and gave birth to a son. She named him Reuben, for she said, "It is because the LORD has seen my misery. Surely my husband will love me now."

³³She conceived again, and when she gave birth to a son she said, "Because the LORD heard that I am not loved, he gave me this one too." So she named him Simeon.

³⁴Again she conceived, and when she gave birth to a son she said, "Now at last my husband will become attached to me, because I have borne him three sons." So he was named Levi.

³⁵She conceived again, and when she gave birth to a son she said, "This time I will praise the LORD." So she named him Judah. Then she stopped having children.

(Genesis 29:31-35)

Reflect

Let's talk about Leah.

When we first meet her, we learn only a few things. She is Rebekah's niece, Laban's eldest daughter, and she has weak eyes, as we read on Day 1. What does that phrase actually mean? Is it that she doesn't see well, as some have suggested? Probably not. Is it that she has been crying because she is not yet married? Maybe, but that's a stretch. There are varying hypotheses, but most scholars who have studied the original phrase in Hebrew think it implies that Leah is simply not a beautiful woman—or at least not as beautiful as her sister.

As a child, were you ever compared to someone else unfavorably? If so, describe it briefly below.

How has this comparison affected you?

My guess is that Leah, as the less attractive sister, felt the sting of comparison many times in her life. I suppose there is a chance that it didn't bother her. Maybe she was mature enough to rejoice in her sister's beauty and be content in who she was. But let's face it, that's a tough thing for any gal to do. She had probably become accustomed to the labels associated with a woman of "weak eyes."

After her marriage, Leah also carried another pain.

Reread Genesis 29:31a (page 26). What does this verse tell us that would have added to Leah's pain?

Leah was the unloved wife. Surely Leah shed many tears in her tent wishing for a different life. In our time of focus today, we read from the New International Version, "When the Lord saw that Leah was not loved, he enabled her to conceive" (v. 31). But in the King James Version it says, "When the Lord saw that Leah was hated, he opened her womb." This version stings even more. The word *hated* carries so much emotion.

Whichever translation you prefer, the good news is that God saw her and blessed her. It's a messy situation, but God is good even in our hardest

God is good even in our hardest moments.

moments. In fact, He seems to specialize in taking our brokenness and turning it into something incredible. That's what happened for Leah.

In the remaining verses of Genesis 29, we see that Leah had four sons in quick succession.

Read Genesis 29:32-35 (page 26) and list Leah's four sons below, along with a summary of what Leah said at the birth of each one:

<u>Name</u> <u>Summary of What Leah Said</u>

1.

2.

3.

4.

From Leah's remarks at the birth of each child, we see that she hoped to gain the approval of her husband.

Genesis 29:32 says, "Leah became pregnant and gave birth to a son. She named him Reuben, for she said, 'It is because the LORD has seen my misery. Surely my husband will love me now.'" But he didn't.

She then gave birth to two more sons, Simeon and Levi, still hoping she would win Jacob's affection. In Genesis 29:33 we read, "'Because the LORD heard that I am not loved, he gave me this one too.' So she named him Simeon." And verse 34 says, "'Now at last my husband will become attached to me, because I have borne him three sons.' So he was named Levi." But again, her husband does not.

Then, at the end of chapter 29, we see a subtle but powerful change. Leah has a fourth child, another son, whom she names Judah; and upon his birth she doesn't look to Jacob for validation. Instead she says, "This time I will praise the LORD" (v. 35).

At the birth of Judah, Leah thanked the Lord instead of grasping for the approval of those around her. Having the love of those around her would have been awesome. But she had tried and failed to reach that goal. So, Leah shifted her focus. At the birth of this fourth child, Judah, she turned her attention to the Lord. No longer was she trying to earn love. Now it was praise she wanted to give. At the birth of Judah, Leah praised the Lord!

And God continued to bless Leah.

Read Genesis 30:17-21 in the margin. How did God continue to bless Leah?

We learn that later Leah had two more sons, Issachar and Zebulon, and a daughter, Dinah.

Some of you have been longing for the approval and love of a parent, spouse, child, or friend for years, but it hasn't happened. I encourage you to continue to pray for that to happen—*and* to choose to realize that even if it doesn't, God is enough to fill the hole that hurt has created. You can be complete because God is enough.

What emotional hole do you need God to fill today?

Write out your prayer asking God to fill your heart here:

17 God listened to Leah, and she became pregnant and bore Jacob a fifth son. 18 Then Leah said, "God has rewarded me for giving my servant to my husband." So she named him Issachar.

19 Leah conceived again and bore Jacob a sixth son. 20 Then Leah said, "God has presented me with a precious gift. This time my husband will treat me with honor, because I have borne him six sons." So she named him Zebulun.

21 Some time later she gave birth to a daughter and named her Dinah.
Genesis 30:17-21

Leah couldn't change the circumstances she found herself in. She couldn't change the hearts of her family. But she came to realize that she could change herself. You can do the same. At the birth of Judah, Leah chose to reach out to God rather than to seek the approval of anyone else. Instead of wallowing in the hurt of what she didn't have, she praised God for what she did.

Take a moment to praise God for what you have. Make a list or write a prayer of praise below:

I like to imagine Leah sitting outside her tent one warm day with Judah as a newborn and three little toddler boys running around playing tag. She had been sad so long. She had yearned for her husband's affection and, perhaps, her sister's friendship. But that hurt had now faded and her heart had been filled with joy for what was in front of her. Instead of focusing on her hurt, she recognized God's gifts. God had seen her and blessed her.

Jacob eventually had twelve sons between his two wives and their maidservants. Rachel didn't remain forever barren. These twelve sons become the twelve tribes of Israel. It's an impressive yet super-dysfunctional family. Of these twelve sons, six are born to Leah. And it's from Leah's sons that we have two very distinguished tribes: the Levites, who cared for the functions of the Temple, and the Judahites, the royal tribe from which David, Solomon, Josiah, and eventually Jesus were born.

Leah's life was messy, but she gave her messiness to God. Her legacy now lives on as the mother of the tribe of Judah. What messes do you need to give to God? What pain has stolen your joy? Today, as you begin a time of prayer, ask God to take the pain of the past and help you see the promise of the future.

Pray

God, like Leah, my life has had moments of deception, emptiness, loneliness, and rejection. I don't want to carry those hurts in my heart any longer. Today I ask you to heal the pain those wounds have created. I want to replace the sting of those hurts with the hope and joy of your love. Fill me. Help me to forgive and move forward in ways that make you smile. Thank you, Lord. Like Leah, I will praise you! Amen.

DAY 4

Settle

Try something new to help you settle today. Take a walk outside and listen to the sounds of life around you, or walk through your home and thank God for the good memories that have been made there. Look for God's fingerprints in the ordinary today and thank God for His presence in your everyday life.

Focus

[16]Now Laban had two daughters; the name of the older was Leah, and the name of the younger was Rachel. [17]Leah had weak eyes, but Rachel had a lovely figure and was beautiful. [18]Jacob was in love with Rachel and said, "I'll work for you seven years in return for your younger daughter Rachel."

[19]Laban said, "It's better that I give her to you than to some other man. Stay here with me." [20]So Jacob served seven years to get Rachel, but they seemed like only a few days to him because of his love for her.

(Genesis 29:16-20)

Read Genesis 30:1-24 (the baby-making contest).

[34]But Rachel had taken the household idols and hidden them in her camel saddle, and now she was sitting on them. When Laban had thoroughly searched her tent without finding them, [35]she said to her father, "Please, sir, forgive me if I don't get up for you. I'm having my monthly period." So Laban continued his search, but he could not find the household idols.

(Genesis 31:34-35 NLT)

A heart at peace gives life to the body,
but envy rots the bones.
(Proverbs 14:30)

[11b]I have learned in whatever situation I am to be content. [12]I know how to be brought low, and I know how to abound. In any and every circumstance, I have learned the secret of facing plenty and hunger, abundance and need. [13]I can do all things through him who strengthens me.

(Philippians 4:11b-13 ESV)

Reflect

Let's talk about Rachel.

What do we know of her? Scripture tells us she was a very attractive woman. The Living Bible translates Genesis 29:17 this way: "Rachel was shapely, and in every way a beauty." We know she was Rebekah's niece, Laban's younger daughter, Leah's sister, and the love of Jacob's life. Apparently, Jacob was immediately captivated by Rachel upon their first meeting.

Read Genesis 29:1-11. Where did Jacob and Rachel first meet? How do we know Jacob was captivated by Rachel?

Jacob and Rachel met at a well in Samaria, the same well where Jesus, many years later, would have an encounter with a Samaritan woman. From the start Jacob seems captivated by her. Upon their first meeting in Genesis 29 Jacob is overcome with emotion, kissing Rachel and weeping at her arrival. It must have been flattering that Jacob was willing to work seven years to win Rachel's hand in marriage—and then, after Laban pulled the bridal switcheroo, to work another seven years. Rachel had the heart of her husband. What she did not have was his children.

Turn again to Genesis 30:1-24. How do we see the rivalry between the sisters play out in these verses? What does each sister do?

Comparison steals joy and leaves us wanting more. It leads us to feel discontent with our current situation and makes peace seem elusive.

Both Rachel and Leah were plagued with the same demons: envy and jealousy. Leah was envious of the love Jacob had for Rachel. Rachel was jealous of Leah's fertility. They both fell victim to the comparison trap. Comparison steals joy and leaves us wanting more. It leads us to feel discontent with our current situation and makes peace seem elusive.

According to Proverbs 14:30 (page 31), what is the result of envy? of a heart at peace?

For me, envy and jealousy are emotions that tend to strike close to home. Perhaps, with the rise of social media, some may find themselves comparing themselves to national and international figures. But, for most of us, our jealousies probably can be traced to comparisons found closer to home with friends and relatives.

In what areas of your life do you find yourself playing the comparison game—perhaps wanting what someone else has?

How have comparison and jealousy affected you in the past—physically, mentally, emotionally, and spiritually?

I often hear people say their favorite verse is Philippians 4:13 (ESV): "I can do all things through him who strengthens me." That is a great promise, but it's important to read the full passage, because the context is actually a challenging one.

Reread Philippians 4:11-13 (page 31), and explain Paul's meaning in verse 13 in light of the verses that precede it:

Paul was painting a much bigger picture when he wrote about facing "plenty and hunger, abundance and need" (v. 12 ESV). He was pointing out that he had learned how to deal with difficult, humbling times. He needed the basics—food, shelter, clothing. It was in the context of those experiences that he said he could do all things through Christ. This passage is about facing hardship with an attitude that says *God is enough*.

When have you been in a low place?

What do you think is required for you to learn to be content?

Years ago, my husband, Jim, and I took our children, Alyssa and Joshua, on a mission trip to El Salvador. Our primary reason for visiting was to meet the children and staff of a children's home our church was helping to support. When we arrived, our hearts were immediately captivated. The children were precious!

There were about twenty-five children living as one family in a home. Thirteen of them were girls under the age of twelve. I noticed right away that the girls were sharing one doll. There were no more. It was a ragged, dirty toy that had obviously been someone else's discarded item. I wanted to take it away from them for sanitary reasons, but then I noticed something amazing. They were voluntarily taking turns caring for the doll. One would pretend to feed her. The next would pretend to dress her (there were no clothes for the doll). They each took a turn loving on this toy, and there was joy.

A few days later we took the children to a store and asked if each of them would like a doll of their own. Of course, they did. They were children after all. We then were able to quietly take the old, dirty, and kind-of-scary doll away. When we returned to the home, I was concerned that we had accidentally

created a problem. The dolls were not the same. Some were babies, some had dark skin, others had lighter tones. Some said mama, others did not. How would it play out? To my relief, the girls began to play with their dolls and then passed them around so that their friends could play as well. It was a simple and kind act. No jealousy, at least not that day.

These children had come from nothing. Most of them had been abandoned or given away. They had not known much love. They could have been angry and bitter. Yet, they seemed to be thankful for the small moments in life. They found joy in things that most of us would take for granted. Their tender hearts taught me, and especially my children, a great deal about what is important in life.

As we left, I asked if I could keep the old doll. In fact, I still have her. She resides in a drawer in my office. On days when I am feeling overwhelmed, unappreciated, or jealous of what others are doing with their lives, I pull her out and remember. I remember that comparison is a trap. I remember that joy can be found anywhere if you just look for it. Even in a doll that looks like a prop for a horror show.

So how does my El Salvador experience relate to today's focus on Rachel? It's the idea of contentment versus jealousy. As we saw at the birth of Judah, Leah began to praise the Lord. Surely, she vacillated from time to time. But with the birth of her fourth son she seemed to have found a new sense of peace by resting in God's goodness.

Rachel, however, is a different story. In the last part of chapter 31, we read about Jacob and his wives and children leaving Laban and heading back to Jacob's home. As they leave, Laban chases them down and wants to know who stole his idols.

Reread Genesis 31:34-35 (page 31). Who stole the household idols, and what did Rachel do to conceal them?

Eventually, God gave Rachel a son, Joseph—who later would become governor of Egypt and save his entire family from a famine by allowing them to make their home in Egypt. She also had a second son, Benjamin, but she died shortly after his delivery.

It's easy to feel sorry for Leah. She was the unchosen, less attractive sister. But I also feel sorry for Rachel. Although, undoubtedly, she was gorgeous and loved by her husband, I wonder if she ever found lasting peace or joy. We can only guess as to the state of their hearts as they aged. Hopefully, they both found contentment in God and perhaps even reconciled their own relationship.

The entire story of Jacob—including his parents, brother, wives, in-laws, and even his children—is messy, to say the least. How much easier would their lives had been if they had found what Paul did—contentment? For that matter, how much easier would *our* lives be if we learned to be content in whatever circumstance we find ourselves?

How can you be content today? Where can you find joy?

Friend, I hope that today, through Christ's strength, you will seek to be content with whatever the world brings your way. Remember that God loves you, and in Him you are beautiful and more than enough!

Pray

- Just be still.
- Thank God for turning your messes into masterpieces—even if you can't see it yet.
- Seek God's forgiveness for the sins that have made a mess of your life.
- Song Suggestion: "Chain Breaker," recorded by Zach Williams

DAY 5

Settle

It's easy to focus on the parts of our story that we don't like, or where we have been hurt. Instead of doing that, begin today by thanking God for the people who have given you love and helped you on your spiritual journey. Allow those thoughts of gratitude to refresh your soul.

Focus

[9]After Jacob returned from Paddan Aram, God appeared to him again and blessed him. [10]God said to him, "Your name is Jacob, but you will no longer be called Jacob; your name will be Israel. So he named him Israel.

[11]And God said to him, "I am God Almighty; be fruitful and increase in number. A nation and a community of nations will come from you, and kings will be among your descendants. [12]The land I gave to Abraham and Isaac I also give to you, and I will give this land to your descendants after you."

(Genesis 35:9-12)

God decided in advance to adopt us into his own family by bringing us to himself through Jesus Christ. This is what he wanted to do, and it gave him great pleasure.

(Ephesians 1:5 NLT)

If you confess with your mouth that Jesus is Lord and believe in your heart that God raised him from the dead, you will be saved.

(Romans 10:9 ESV)

Reflect

Let's talk about God.

This week we've dug into the story of siblings thrust into a love triangle. The results were a family scarred by jealousy, rivalry, deceit, and even hatred. Those traits not only affected them but also were passed from one generation to the next. How can anything good come from that? The answer is God. God showed up, as He has a way of doing, and from their mess a masterpiece was created.

Let's make the story of Rachel and Leah personal today.

Values are caught, not taught.

Values are caught, not taught. I heard this phrase years ago, and it rang true for me. We can extol wisdom and lay down guidelines for our children, but what they really learn is what they see and experience. Values and behaviors are much more easily caught than taught.

I've experienced this to be true in big and small ways. For instance, parents who are kind and honest often raise children with great integrity. Children who eat healthy often have parents who are concerned about nutrition. Kids who are talkative often have parents who are much the same.

On the other hand, in households where there was hitting and yelling, that pattern is often repeated. Families with a poor work ethic often raise lazy kids. You get the idea. We learn what we live, the good and the bad. Values are more often caught than taught. And this can create generational cycles.

As we've seen this week, Leah and Rachel caught what was taught around them. Their husband (Jacob), father (Laban), mother-in-law (Rebekah), and they themselves suffered the consequences of favoritism and deception. In their lives we see lying, manipulation, and even hatred. That kind of sin and dysfunction creates broken hearts and hardened spirits. It splits families apart and can have long-lasting effects.

Their sons through Jacob further illustrated this point. They picked up their parents' traits of lying, jealousy, and hatred. They even went so far as to sell their younger brother Joseph into slavery and then straight-out lied to their father about it (see Genesis 37:25-36). That is extreme dysfunction!

Jacob's family had its issues. They were very messy people. But God loved them and did not stop pursuing them. Both Rachel and Leah were blessed with sons and, after wrestling with God, Jacob received a blessing too.

Reread Genesis 35:9-12 (page 37). How did God bless Jacob?

God changed Jacob's name to Israel, which means "one who struggles with God,"[1] and God promised he would become the father of many nations. This fulfilled a promise God had given to his grandfather, Abraham.

Write God's promise to Abraham found in Genesis 12:1-3 (in the margin):

Now write God's promise to Jacob, renamed Israel, found in Genesis 35:11-12:

From this messy lineage came kings, prophets, warriors, and heroes. Also from this lineage came the Messiah! Jesus is a direct descendant of Leah's offspring! Why would God bless such a messy family in such a powerful way? It's because God chooses and uses messy people! (Again, it's all he's got to work with!)

What generational messes have you had to contend with? (Examples might be addiction, lying, apathy, lust, and so forth)

What generational cycles do you want God to break through you?

Is there something God is inviting you to forgive in order to move forward? (Remember that forgiveness does not always mean reconciliation.) Write a prayer below, asking for God's help:

[1] *The Lord had said to Abram, "Go from your country, your people and your father's household to the land I will show you.*

[2] *"I will make you into a great nation,*
and I will bless you;
I will make your name great,
and you will be a blessing.
[3] *I will bless those who bless you,*
and whoever curses you I will curse;
and all peoples on earth will be blessed through you."
Genesis 12:1-3

What next step is God inviting you to take on the journey from messy to masterpiece?

As we close this first week together, friend, I want to encourage you. You are loved. You are chosen. And you have a place in God's family if you choose to accept it!

Reread Ephesians 1:5 (page 37) and fill in the blanks below:

"God decided in advance to _____ us into his own _____ by bringing us to himself through Jesus Christ. This is what he wanted to do, and it gave him great _____."

Now, write your name in the blanks below and read the verse aloud several times, claiming it for yourself!

"God decided in advance to adopt _____ into his own family by bringing _____ to himself through Jesus Christ. This is what he wanted to do, and it gave him great pleasure."

Friend, God wants *you* in His family! He can take whatever heartaches, dysfunction, and sin that have marked your past and wash it white as snow. All you have to do is confess and believe.

> *If you confess with your mouth that Jesus is Lord and believe in your heart that God raised him from the dead, you will be saved.*
>
> (Romans 10:9 ESV)

When you confess and believe the truth about Jesus, you *want* to repent of your sins and ask Jesus to become not only your Savior but also your Lord—the CEO of your life. He's a CEO you can trust, because His decisions will always be in your best interest!

Pray

Dear Jesus, thank You for loving me. Help me understand what it means to follow You with my whole heart. I want to move past the messes of my life. Today I give my life to You, whether for the first or the ninety-first time. I receive what was done for me on the cross. Wash me clean. Please forgive me, lead me, and give me new joy in You. Help me to be the one to break cycles in my family and to do it in a gentle, loving way. In Your name and through Your power. Amen.

Video Viewer Guide: Week 1

1. Be really _____ for what you already have.

8Finally, brothers and sisters, whatever is true, whatever is noble, whatever is right, whatever is pure, whatever is lovely, whatever is admirable—if anything is excellent or praiseworthy—think about such things. 9Whatever you have learned or received or heard from me, or seen in me—put it into practice. And the God of peace will be with you.

(Philippians 4:8-9)

11I am not saying this because I am in need, for I have learned to be content whatever the circumstances. 12I know what it is to be in need, and I know what it is to have plenty. I have learned the secret [pay attention here] of being content in any and every situation, whether well fed or hungry, whether living in plenty or in want. 13I can do all this through him who gives me strength.

(Philippians 4:11-13)

2. Make it a practice to _____ when others receive a blessing.

"Rejoice with those who rejoice; and mourn with those who mourn."

(Romans 12:15)

WEEK 2

Moses

Learning to Trust God

Exodus 1–17
Numbers 11; 20

Memory Verse

So do not fear, for I am with you;
 do not be dismayed, for I am your God.
I will strengthen you and help you;
 I will uphold you with my righteous right hand.

(Isaiah 41:10)

DAY 1

Settle

Close your eyes and let your mind go to a pleasant place. Gently rest in that peaceful feeling while turning all your energy toward God. Allow peace to envelop you as you begin this time with the Lord today.

Focus

Read Exodus 1 and Exodus 2:1-15.

⁶Now Joseph and all his brothers and all that generation died, ⁷but the Israelites were exceedingly fruitful; they multiplied greatly, increased in numbers and became so numerous that the land was filled with them.

⁸Then a new king, to whom Joseph meant nothing, came to power in Egypt.

(Exodus 1:6-8)

⁵Then Pharaoh's daughter went down to the Nile to bathe, and her attendants were walking along the riverbank. She saw the basket among the reeds and sent her female slave to get it. ⁶She opened it and saw the baby. He was crying, and she felt sorry for him. "This is one of the Hebrew babies," she said.

(Exodus 2:5-6)

Reflect

What are you passionate about? What issues in the world really get you stirred up and leave you aching to make a difference?

For me, it usually involves children. Those with special needs, those who don't live in a safe home, and especially those who don't have the love of a parent really tug on my heartstrings. These issues make me want to get involved.

For years I asked God how He wanted me to get involved with the needs of children. But the needs were so overwhelming. How could I, just one person, make a difference? My husband and I seriously considered adopting. In fact, we began the process only to hit many dead ends. Additionally, the church we lead was booming, and that demanded a great deal from us. We really didn't know how we would juggle anything more. So, my heart ached. Why would God give me this burden to help kids only for me to meet so many obstacles?

One day in my frustration of wanting to adopt, or at least help in some way, God spoke to me—not audibly, but clearly. He said, "Jen, if you keep pressing, you'll figure out a way to adopt.

But if you'll wait for me, I have a way you could help not just one child but thousands."

That was sweet but confusing. How could that possibly happen? The message was clear, though: "If you'll wait for me. . . ." I needed to wait on the Lord's timing. So, I relaxed and had faith that the passion God planted inside me would find a way to bloom.

It wasn't long after hearing from God that Jim and I were invited to be part of Compassion International, which is an organization dedicated to helping children thrive—and doing that in Jesus's name. We had questions, though. Where does the money go? Do the children really get the help? Can we trust this organization? So, before asking our church to get involved, we went to see for ourselves. Literally, we went to Africa and met the child we sponsor. The one whose picture hung on our refrigerator. We looked at the financial records and asked our questions, and we were pleased with all we learned. We were hooked!

Over the years we have shared our experiences and invited our congregation to get involved with both sponsorship and special projects. Can you guess how many children have been affected to date? Thousands!

It's only in retrospect that I can see that God was setting this up all along. The way my heart ached, the timing, the strategic partner, the opportunity—it was all Him! Isn't it great when God shows up and says, "Want to make a difference together?"

Now it's your turn. What are you passionate about? What issues in the world make your heart ache?

Who (or what organization) is currently doing something in this area that you could learn from?

What is keeping you from making a difference in this area?

The first book of the Bible, Genesis, ends in victory. The people of God survived a famine in Israel and found a new home in Egypt. Jacob's son Joseph, although originally sold into slavery by his brothers, rose to great heights in this foreign land and found great favor with the pharaoh of Egypt. God's people thrived there—at least for a while.

When the second book of the Bible, Exodus, opens, it doesn't take us long to see that the scene has drastically changed.

Reread Exodus 1:6-8 (page 45). What foreboding clue do we find in verse 8?

Four hundred years had passed, the Israelites had grown in number, and the new pharaoh had no ties to Joseph or his descendants. That is a big clue that unfavorable change was on the horizon! The new pharaoh decided to put an end to the Hebrews' fruitfulness by enslaving them and treating them harshly. Then he took things one horrible step further.

Read Exodus 1:15-16 in the margin. What did the pharaoh order?

The pharaoh ordered male infanticide, a fancy way of saying he set out to kill all the newborn boys. What a nightmare for any woman who found herself pregnant at this time in history! What despair the months of pregnancy must have brought! While most women look forward to the birth of their children, these women would have lived in fear of the delivery. What if it was a boy? Having a son myself, I can't imagine having him ripped from my arms after delivery. What true horror!

In chapter 2 of Exodus, we meet our messy person of the week, Moses.

Read Exodus 2:1-4 in the margin. According to verse 2, what did this mother recognize about her child, and what did she do?

[15] The king of Egypt said to the Hebrew midwives, whose names were Shiphrah and Puah, [16] "When you are helping the Hebrew women during childbirth on the delivery stool, if you see that the baby is a boy, kill him; but if it is a girl, let her live."

Exodus 1:15-16

[1] Now a man of the tribe of Levi married a Levite woman, [2] and she became pregnant and gave birth to a son. When she saw that he was a fine child, she hid him for three months. [3] But when she could hide him no longer, she got a papyrus basket for him and coated it with tar and pitch. Then she placed the child in it and put it among the reeds along the bank of the Nile. [4] His sister stood at a distance to see what would happen to him.

Exodus 2:1-4

What was her next plan, and what happened?

Now, there is no doubt that Moses was a special child, but what mom doesn't feel the same way? I certainly do. And if you're a mom, I'll bet you do too. I appreciate and relate to Moses's mom. She took risks and went to great lengths to protect her child, hiding him for three months and then placing him in a basket along the bank of the river where she knew he would be found. She even sent his sister to keep watch. As a result, Moses not only survived but was found by Pharaoh's daughter.

Now read Exodus 2:5-10. What happened after Pharaoh's daughter found baby Moses in the basket?

What a sweet gift that Moses's mother received in being able to see her child saved, and the opportunity to nurse him. We don't have the details of how Moses grew up, but surely being raised by Pharaoh's daughter brought privilege. Moses did not live under the whip of the slave master as his Hebrew brothers and sisters did, but he seemed to know his identity lay in Israelite heritage.

Read Exodus 2:11-12. How do these verses support the idea that Moses knew of his heritage? How do they help to explain—not justify—Moses's actions?

Moses acted on this day as he saw one of his own being beaten. Perhaps he couldn't take it anymore—witnessing the beatings and abuse of the Hebrew slaves. Maybe he could stand idly by no longer. My guess is that Moses's heart ached at the plight his fellow Hebrews had suffered that he had witnessed from a young age. And on this day, as he saw a fellow Hebrew being

beaten, he snapped. The anger, the outrage, the feelings of the injustice of privilege bubbled up and came out in a murderous way. (Though this is not the right way to go about justice reform, of course.)

Describe a time when your own anger spilled over and you made a mess of things:

How did you try to make it right?

Are you more likely to try to hide your sins or to confess them and seek forgiveness? Why do you think you respond this way?

Moses tried to keep his sin a secret, but sins don't usually stay hidden for long.

Read Exodus 2:13-15. How did Moses discover that what he had done was no longer a secret? What happened next?

When Pharaoh heard what Moses had done, he put out a kill order. So, Moses ran. The future hero of the Hebrew nation was a murderer and a fugitive. Indeed, he was a messy person!

Moses ran straight to Midian, a safe place where he would be able to learn more about the ways of the Hebrew people and hear from God.

Yes, Moses made mistakes. Big ones. He, like David, Noah, and other biblical giants, did not always get it right. But what they did well is learn and grow from their mistakes. That's what I want to do also. When I mess up—not *if* I mess up, but *when*—I want to confess it and get back to walking securely in step with God's will. How about you?

From start to finish this week we will see that Moses's life was messy. He made mistakes, but he also learned to walk incredibly close to God. Notice the word *learned*. His faith and maturity were not automatic. It took time for him to move past his own emotions. He experienced anger, as we've seen today. He also had insecurities, fear, excuses, and critics. He had to learn to deal with each of these and move through them.

Moses's life was indeed a messy one, but what a powerful example he is of someone who struggled and prevailed through faith. In fact, Deuteronomy 34:10 (NLT) says of him, "There has never been another prophet in Israel like Moses, whom the Lord knew face to face."

As we move through Moses's life this week, ask God the question I mentioned in the introduction: *So, what*? In other words, so what can I learn here? So, what can I apply in my life? So, what does this encourage me to do moving forward? So, what do I feel conviction about in how I handle things? So, what am I passionate about? So, what are you calling me to do, Lord? These questions will help you personalize the lessons of Moses and discover how to apply what he learned in your own life.

We're all messy, friends. What we must learn is how to deal with our messes in ways that honor God—so that God can turn them into masterpieces! And perhaps along the way we will learn to avoid unnecessary messes in the future!

Pray

- Thank God for His presence in your life.
- Ask Him to begin revealing or giving greater clarity about where you can make a difference in the world.
- Seek His forgiveness in areas you have been disobedient or apathetic in following Him.
- Close with a time of simply thanking Him for who He is.

DAY 2

Settle

As you quiet your heart before the Lord today, ask Him to bring an enveloping peace over you. Just sit in His presence a few minutes to allow Him to give you rest from the day.

Focus

Read Exodus 2:15–4:12, the story of Moses's flight to Midian and encounter with God in the burning bush.

> Moses said to God, "Who am I that I should go to Pharaoh and bring the Israelites out of Egypt?"
>
> (Exodus 3:11)

> Moses said to God, "Suppose I go to the Israelites and say to them, 'The God of your fathers has sent me to you,' and they ask me, 'What is his name?' Then what shall I tell them?"
>
> (Exodus 3:13)

> Moses answered, "What if they do not believe me or listen to me and say, 'The Lord did not appear to you'?"
>
> (Exodus 4:1)

Reflect

Have you ever felt God calling you to do something but you hesitated? At times when God has spoken to me, I have hesitated. Instead of saying yes, my fears took over. Excuses kicked in. Then the justification of the excuses. Sound familiar? Often our hesitations stem from feeling inadequate, unqualified, or just plain afraid. Or maybe, if we're being honest, we doubted that God would have our back if we stepped out in faith. And since we're being honest, we may have to admit that at times our hesitation was simply because we didn't want to do what God was asking of us.

Moses could relate to these feelings. After he ran from Egypt, Moses had a dramatic encounter with God at a burning bush. If you grew up in church or

have heard the story before, the burning bush reference may be so familiar that it doesn't catch your attention. But think about it: speaking through a bush that is on fire yet doesn't burn is a pretty big deal! So, ponder that crazy miracle for just a moment. In this epic meeting, God revealed His name, His promise, and His mission for Moses.

But Moses hesitated. Instead of responding in faith, Moses offered God excuses.

It would be easy to judge Moses harshly. But the truth is, as I've already admitted, I've also offered excuses to the Lord. I'm guessing you have too. So, we won't judge him. Instead, why don't we examine his story and see what we can learn?

Let's look at the five excuses Moses offers to God and see if we, too, may be guilty of these at times. We'll cover three of them today and then hit the other two tomorrow.

Excuse #1: I'm not good enough.

> *Moses said to God, "Who am I that I should go to Pharaoh and bring the Israelites out of Egypt?"*
>
> *(Exodus 3:11)*

This is an excuse I can relate to. I have often asked questions like, *Who am I, Lord, to write a women's Bible study? to speak to this crowd? to parent these precious children? Who am I that you could use me?*

What are some of the questions that have served as excuses for *you*?

Excuses may seem like humility at first glance, but they are not. They reveal a lack of faith, not only of who we are but also of who God can be in our lives.

Excuses may seem like humility at first glance, but they are not. They reveal a lack of faith, not only of who we are but also of who God can be in our lives.

Choose one of the excuses you wrote on the previous page. What does it reveal about something you are not believing or trusting—about yourself or about God?

Are you good enough? No. Neither am I. Neither was Moses. But—and this is important—with God's power at work in you, you are *more than enough.* You are qualified because God has qualified you. He will give you the tools, wisdom, and strength to be more than enough.

Look up Exodus 3:12 and write God's response below:

I will _____ _____ _____.

God gave Moses a promise, the same promise you can claim today as you walk with the Lord. God is with you! God was not calling Moses to face down Pharaoh alone. He promised to empower and protect Moses.

When have you felt God calling you to partner with Him but you were hesitant because you just didn't feel good enough? What happened?

How might God be calling you to partner with Him now? Write a prayer below, acknowledging that God will be with you and give you all you need to be more than enough.

With God's power at work in you, you are *more than enough.*

Excuse #2: I don't have all the answers.

Moses said to God, "Suppose I go to the Israelites and say to them, 'The God of your fathers has sent me to you,' and they ask me, 'What is his name?' Then what shall I tell them?"

(*Exodus* 3:13)

God wants us to move obediently— and to do it trusting Him.

So often when God calls us to move, we want to see the entire plan laid out before us. What do I do? How do I respond to critics? We want all the answers in advance—a clear road map for the entire journey. But if we had all the answers and outcomes in advance, no faith would be required. God wants us to move obediently—and to do it trusting Him.

When have you wanted the plan or the answers in advance before saying yes to God?

Moses knew that he didn't have all the answers, and that made him afraid to partner with God. This is where trust in *who God is* came into play.

Look up Exodus 3:14 and write God's response below:

I AM _____ _____ _____.

God, the one speaking through the bush that was on fire yet wasn't being burned up, said, "I AM WHO I AM." In other words, my name is Yahweh, which means "He who is" or "He who causes to be."[1]

It's hard for us to wrap our minds around all that this name conveys: eternal, all powerful, sovereign, and trustworthy. That's only scratching the surface of our amazing God who causes all things to be. What God's name tells us is that God can be trusted.

I have spent many hours in the pool teaching children to swim, and I've had success with all of the children I've tried to instruct except one. It wasn't that she didn't have the strength or even the skill. It came down to one thing—she didn't trust me enough to let go. She didn't know what would happen if I let go of her, so she wouldn't try. She didn't have all the answers to what would happen if she tried, so she stayed in the shallows.

When have you stayed in the shallows because you weren't willing to let go and trust God? What happened?

How might God be calling you to move out of the shallows and into unknown waters now? Write a prayer below acknowledging the aspects of God's character that will help you to trust Him:

Excuse #3: I might be criticized.

Moses answered, "What if they do not believe me or listen to me and say, 'The LORD did not appear to you'?"

(*Exodus 4:1*)

This one hits deeply for me. Who wants to be criticized? Not me! Moses was afraid his actions and motives would be questioned—which they were, by the way. He anticipated rejection and wanted to avoid it. Again, I feel that deeply. But real heroes of faith are willing to face that criticism and move with God anyway.

When have you hesitated to obey God because you were afraid of criticism and the opinions of others?

Read Exodus 4:2-9 and summarize in your own words what God's response was to Moses's fear of criticism.

God promised to perform miraculous signs. Now, God didn't have to do this. I imagine He may have wanted to say, "Hey, man, just go and do the job." But in His sweetness, God gave Moses two signs and promised a third sign to prove that He had sent him.

Refer again to Exodus 4:2-9 and fill in the blanks to identify these three signs:

turning Moses's staff into a _____ and back into a staff,

making Moses's hand _____ and then restoring it, and promising

to turn _____ from the _____ into _____.

God turned Moses's staff into a snake and back again, made Moses's hand leprous and then restored it, and then promised to turn water from the Nile into blood if they did not listen or believe the first two signs. In advance, God showed Moses that He could be trusted.

You may not always have that experience. But you probably can look back on your life and see where God has been faithful in the past to know that He will be at work in your life in the future. Then you can take these holy moments from your past as your sign to move forward in faith when you know God is calling you to action.

Is there a circumstance in your life where criticism, or the fear of criticism, is impacting your faithfulness?

List some moments from your past where God has been faithful that can encourage you to move forward in faith today:

Today our focus has been on three of the excuses Moses gave to the Lord for why he could not be used to fulfill God's purposes. Which resonates most with you?

Circle the excuse that you tend to give God most often:

I'm not good enough.

I don't have all the answers.

I might be criticized.

We may be guilty of all three excuses at times. But often there is a particular excuse that we tend to give on a regular basis. By identifying which one it is and then talking with God about our fears and listening to God's reassuring responses—just as Moses did—we can begin to move forward in greater trust and confidence. Moses eventually moved past his excuses. My hope is that we all will do the same. As we do so, the mess of our excuses will become the masterpiece of God's handiwork!

Pray

God, help me see myself clearly. Expose in me, and to me, where I have been guilty of using excuses to keep me from partnering with you. Forgive me for being hesitant to move in step with you. Today I say, "Use me!" Amen.

DAY 3

Settle

Listen to a song that brings you joy—maybe an old hymn. "Trust and Obey" would be a good one today. Or listen to something more contemporary. You may enjoy "Trust in God" by Elevation Worship.

Focus

"Pardon your servant, Lord. I have never been eloquent, neither in the past nor since you have spoken to your servant. I am slow of speech and tongue."

(Exodus 4:10)

[13] But Moses again pleaded, "Lord, please! Send anyone else."

[14] Then the Lord became angry with Moses. "All right," he said. "What about your brother, Aaron the Levite? I know he speaks well. And look! He is on his way to meet you now. He will be delighted to see you. [15] Talk to him, and put the words in his mouth. I will be with both of you as you speak, and I will instruct you both in what to do. [16] Aaron will be your spokesman to the people. He will be your mouthpiece, and you will stand in the place of God for him, telling him what to say. [17] And take your shepherd's staff with you, and use it to perform the miraculous signs I have shown you."

(Exodus 4:13-17 NLT)

"If any of you wants to be my follower, you must give up your own way, take up your cross daily, and follow me."

(Luke 9:23 NLT)

Reflect

I have the privilege of speaking often at my home church. But I have a confession to make. On the weekends that I'm to bring the message, I become incredibly nervous. In my anxiety I entertain thoughts like, *Who are you to speak to these people? Isn't there someone better to do this?* or *I'll probably mess it up anyway!* Most people who know me would find this hard to believe, but it's real; and at times it has been debilitating. So, I've had to develop coping skills to deal with the anxiety that I have about being in front of crowds of people. I tell

myself things like, *No, you're not good enough, but God is good. So, go tell these people about Him,* or, *it doesn't matter if someone criticizes you. Do it anyway.* Or how about this one—*God has invited you to share about Him. Get over yourself and do this thing with gladness and watch how God shows up.* (That one is a regular for me.)

Instead of making excuses about why I shouldn't speak, or write, I have learned to coach myself up. (I do this with a lot of help from my husband. He's quick to gently call me out when I start the excuse business.)

But I know I'm not alone in making excuses. There are many people in the Bible who struggled with the same thing. As we saw yesterday, Moses had plenty of excuses, including saying that he might be criticized (Exodus 4:1). Other examples would be Jonah, who ran away from God's command to preach to Nineveh (Jonah 1:3), and the rich young ruler, who walked away from Jesus when he was told to sell his possessions and follow Him (Mark 10:22). Finally, there's also Gideon, who had an excuse for every occasion (Judges 6:1-16).

Scripture makes it clear: excuses show a lack of faith, trust, and obedience—not to mention they keep us from discovering the best God has planned for us!

Reread Luke 9:23 (page 58). What did Jesus say we must do to follow Him, and what does this require?

Excuses show a lack of faith, trust, and obedience— not to mention they keep us from discovering the best God has planned for us!

Following Jesus means denying yourself and taking up your cross, and this requires trusting and obeying that what God wants is ultimately best for us. As this verse shows us, putting Him first means we are ready to move into action at His invitation. We let go of our excuses and our selfish desires and trust Him with our lives.

Yesterday we examined the first three excuses Moses offered to God:

1. I'm not good enough.
2. I don't have all the answers.
3. I might be criticized.

To recap, Moses was actually right on all three counts. He wasn't good enough, but God was. He didn't have the answers, but God did. And he was

criticized—a lot. But God sustained him through that as well. Today we turn to excuses 4 and 5.

Excuse #4: I'm not qualified.

"Pardon your servant, Lord. I have never been eloquent, neither in the past nor since you have spoken to your servant. I am slow of speech and tongue."

(Exodus 4:10)

For Moses to be effective in leading the Israelites out of Egypt, he would be required to speak publicly. Speaking was not his strong suit. In fact, some scholars believe he was a stutterer. Moses told the Lord he was not eloquent but was "slow of speech and tongue." Moses was aware of his shortcomings and felt that his poor speech would disqualify him from God's service.

When have you felt unqualified for the task God was calling you to?

Did Moses think God didn't know he was slow of speech? Did he think God had overlooked the details? God is always in the details!

Read Exodus 4:11-12, and write below God's response in verse 12:

I will help you _____ **and will teach**

you what to _____.

God wasn't looking for ability but availability. God knew Moses's shortcomings, and He chose him anyway. God promised to help him speak and to teach him what to say. If you have ever felt unqualified, know that it is God who chose you and God who will equip you.

Is there something you feel unqualified to do now? Write a prayer below, acknowledging that God will help you to do whatever it is.

Excuse #5: I just don't want to.

But Moses again pleaded, "Lord, please! Send anyone else."
(Exodus 4:13 NLT)

Well, there it is, plainly stated! Moses didn't want to do what God was asking him to do. Moses had his reasons. Let's call them his excuses. He was a wanted man after killing the Egyptian. He also didn't feel worthy or qualified. But the bottom line was that he just didn't want to do it.

When in the past have you simply not wanted to do something God was asking you to do?

If we are honest with ourselves, and with God, this fifth response is probably the one we are most likely to offer when God invites us into His plans. Sometimes, we are so busy with our own agendas that when God shows up we find it challenging to deviate from our plans to His.

Reread Exodus 4:14-17 (page 58) and summarize in your own words God's response:

God was angry when Moses begged Him to send someone else—anyone else—yet even in His anger God did not give up on messy Moses. God told Moses that He would give him a partner. God chose Moses's brother, Aaron, to accompany him and be his spokesman. And then to show Moses even more kindness, God told him that Aaron was already on the way to meet him.

Is there something you are reluctant to do now that you know God wants you to do?

> **Sometimes, we are so busy with our own agendas that when God shows up we find it challenging to deviate from our plans to His.**

How does knowing that God is already at work providing for your needs encourage you?

Write a prayer below, acknowledging that God knows your needs and is working to address them even now:

Like Moses, we all struggle with excuses. Identifying our excuses and then asking God to help us move beyond them in faith is what moves us from messy to masterpiece. The next time you hear God calling you to partner with Him, don't make excuses. Just say yes and then trust Him to equip you, guide you, and use you for His glory.

Pray

Lord, I confess I have made excuses to avoid partnering with You. I ask for Your forgiveness. Instead of a hesitant heart, I want one that is ready to respond. Help me move past my fears, my critics, and my own insecurities to serve You with joy. I love You, Lord. Today is Yours. What do You want to do together? Amen.

DAY 4

Settle

Let's try something different today. Before you begin this devotional lesson, stand up and stretch. Reach your arms up and get the blood flowing. Take a few deep breaths. Now approach today's time with God with energy and an attitude that says "What's next, Lord?"

Focus

And God said, "I will be with you."
> *(Exodus 3:12a)*

[20]So Moses took his wife and sons, put them on a donkey, and headed back to the land of Egypt. In his hand he carried the staff of God.

[21]And the Lord told Moses, "When you arrive back in Egypt, go to Pharaoh and perform all the miracles I have empowered you to do. But I will harden his heart so he will refuse to let the people go. [22]Then you will tell him, 'This is what the Lord says: Israel is my firstborn son. [23]I commanded you, "Let my son go, so he can worship me." But since you have refused, I will now kill your firstborn son!'"
> *(Exodus 4:20-23 NLT)*

[10]Moses heard the people of every family wailing at the entrance to their tents.... [11]He asked the Lord, "Why have you brought this trouble on your servant? What have I done to displease you that you put the burden of all these people on me? ... [13]Where can I get meat for all these people? They keep wailing to me, 'Give us meat to eat!' [14]I cannot carry all these people by myself; the burden is too heavy for me. [15]If this is how you are going to treat me, please go ahead and kill me—if I have found favor in your eyes—and do not let me face my own ruin."
> *(Numbers 11:10-15)*

So do not fear, for I am with you;
> *do not be dismayed, for I am your God.*
I will strengthen you and help you;
> *I will uphold you with my righteous right hand.*
> *(Isaiah 41:10)*

I'm sure about this: the one who started a good work in you will stay with you to complete the job by the day of Christ Jesus.

(Philippians 1:6 CEB)

The One Who called you is faithful and will do what He promised.

(1 Thessalonians 5:24 NLV)

Reflect

For many years I worked in student ministry. I loved it! It's a safe guess to say that over the years I have been on about one hundred retreats with middle and high school students. Is there an award for that? If not, there should be!

One retreat that particularly stands out was to the mountains of Tennessee. White water rafting, campfires, ropes course, devotionals, capture the flag, and bad food were all part of the experience. Business as usual. But what I remember most about this retreat is that Galatians 2:20 came to life for many of the students:

"My old self has been crucified with Christ. It is no longer I who live, but Christ lives in me. So I live in this earthly body by trusting in the Son of God, who loved me and gave himself for me" (NLT).

After reading this to them, a few of the high school guys came to me and said, "Talk to us about this scripture. What does it really mean for us right now, today?"

It was a great question. I didn't really say much because they immediately began to answer their own question with statements like these:

So, God forgives me for the stuff I've done.
This means I may not turn out like my dad after all.
I get a do-over.
My life is going to make a difference.

Later that night, as kids were sharing, one of the oldest guys said, "This passage, Galatians 2:20, changes everything for me. You guys know who I've been, but God knows who I can be. That's the man I'm going to become. If Christ died for me, then it's up to me to live for him." It was a precious moment, and that's why it has stuck with me all these years.

What messes have previously defined you, at least in your own eyes?

Whom do you feel God is calling you to be now?

The past two days we've looked at the excuses Moses gave to the Lord for why he wasn't usable. Some of those excuses were centered around the debilitating fear of *what if*. What if I don't have all the answers? What if I am criticized? What if my past disqualifies me? What if my gifts aren't enough? God wasn't interested in the what-ifs of Moses, and I've noticed he isn't interested in mine either.

On that retreat, the guys in my group began to switch their language. Instead of being paralyzed by their what-ifs, they began to use that very same phrase to dream. What if I could do something incredible with God's help? What if I could break the cycles of my family? What if I became a godly man? What if God really loves me and wants me to live a great life?

How could you turn a few of your negative what-ifs into what-if possibilities? First, write your negative what-ifs here:

Now, rewrite those what-ifs as positive what-if possibilities:

It was exciting to watch—and even more exciting to see the results show up in their lives years later. Some of them really embraced that moment and began to live into the possibilities of who God wanted them to be and what

In times of discouragement, we have to decide if we're going to give up or trust God to move us through.

He wanted them to do with their lives. They moved past the excuses. What a joy to see that lived out!

It was great to see these youth move forward in faith. However, through the years they have faced challenges. Haven't we all? There have been setbacks and moments of discouragement. Things have not always gone smoothly for them, and they have had to deal with critics and crises. Those setbacks could have quickly become stopping points for them. It's true for all of us. In times of discouragement, we have to decide if we're going to give up or trust God to move us through.

Moses had to do the same thing.

Let's consider his journey. We've seen that he survived the infanticide of the Hebrew boys and escaped to Midian after killing an Egyptian who was mistreating a Hebrew slave (Exodus 2). He experienced God in a bush that was on fire yet didn't burn up (Exodus 3). Then in Exodus 4–11, we read that Moses returned to Egypt and God used him to warn Pharaoh of the ten plagues, which then were carried out. Exodus 12–14 tells us how he led his people out of Egypt and across the massive Red Sea on dry ground.

God had promised Moses that He would be with him (Exodus 3:12). Miracles and provisions had been provided at every turn of the story, including water from a rock to quench the people's thirst (Exodus 17) and manna that appeared on the ground in the mornings to feed them (Exodus 16). But after eating manna for a long time, the people began to complain and ask for meat.

Reread Numbers 11:10-15 (page 63). Listen to Moses's heart as he cries out to the Lord. Then rewrite below what you might have said to God if you were in Moses's shoes:

Moses was tired, and the constant complaining from the people he was leading had worn him down. In that hardship he had become discouraged. He lost sight of all God had done and began to focus on the trouble immediately in front of him.

I am guilty of that too. I get tired. The grumblers wear me down. Discouragement can set in. And that can lead me to want to give up on what God has called me to do. Can you relate?

When has discouragement set in and made you want to give up on what God has called you to do?

It's in moments of discouragement that we need to do what Moses did: cry out to the Lord! Here's a suggestion for what that can look like.

1. Let God know what you are feeling, pouring out your heart to your loving Father.
2. Once you have done that, take a trip down memory lane, remembering all the ways God has been with you in the past. Literally write down all the ways God has been there for you. As the old hymn goes, "count your many blessings, name them one by one."

Take a moment to count your blessings, naming some of them in the margin.

It is good to reflect and remember all of the ways that God has been with us. We can also turn to God's Word and cling to the promises found there, remembering that God assures us of His ongoing faithfulness.

Reread 1 Thessalonians 5:24 (page 64). What does this verse tell us?

Now take another look at Isaiah 41:10 (page 63). In addition to being with us, what three things does God promise to do for us?

I will _____ you.

I will _____ you.

I will _____ you.

Don't let discouragement be a stopping point in your faith story. That's the time to double down in faith.

When the guys from my youth group would get discouraged over the years, these were the passages I would remind them to claim. As I face my own times of discouragement, I try to do the same. I hope you will as well.

Once we move past our negative what-ifs and into our dreaming what-ifs, we will still face challenging times. In those seasons we will experience fatigue and discouragement. It's going to happen. But that's when we push through with God. We don't give up! Claiming verses like 1 Thessalonians 5:24 and Isaiah 41:10, along with crying out to the Lord and remembering His faithfulness in the past, can help us to keep moving forward. Don't let discouragement be a stopping point in your faith story. That's the time to double down in faith.

Moses had low moments. His story is messy. But thanks to God's goodness and Moses's faithful obedience, the outcome of his life is a masterpiece.

Let's close with a reminder from Philippians.

Reread Philippians 1:6 (CEB) (page 64). Now personalize this promise below:

I'm sure about this: the one who started a good work in

_____ *(your name) will*

stay with _____ *(your name)*

to complete the job by the day of Christ Jesus.

Friend, God is the one who called you, and God will see you through. As His child, you can trust Him, just as Moses could. Remember, God is with you, God is for you, and God will complete what He has started in you, creating a masterpiece of your life!

Pray

- Thank God for how He has seen you through difficult times in the past.
- Ask Him to give you wisdom and strength to push through when times of discouragement become overwhelming.
- Now begin to dream with God about what is possible as you continue turning your negative what-ifs into positive what-ifs!

DAY 5

Settle

Thank the Lord for His goodness today. How is He blessing you right now? Thank Him for who He is and all He has done, is doing, and will do out of His love for you.

Focus

*[5]The L*ORD* answered Moses, "Go out in front of the people. Take with you some of the elders of Israel and take in your hand the staff with which you struck the Nile, and go. [6]I will stand there before you by the rock at Horeb. Strike the rock, and water will come out of it for the people to drink." So Moses did this in the sight of the elders of Israel.*

(Exodus 17:5-6)

*[7]The L*ORD* said to Moses, [8]"Take the staff, and you and your brother Aaron gather the assembly together. Speak to that rock before their eyes and it will pour out its water. You will bring water out of the rock for the community so they and their livestock can drink."*

*[9]So Moses took the staff from the L*ORD*'s presence, just as he commanded him. [10]He and Aaron gathered the assembly together in front of the rock and Moses said to them, "Listen, you rebels, must we bring you water out of this rock?" [11]Then Moses raised his arm and struck the rock twice with his staff. Water gushed out, and the community and their livestock drank.*

*[12]But the L*ORD* said to Moses and Aaron, "Because you did not trust in me enough to honor me as holy in the sight of the Israelites, you will not bring this community into the land I give them."*

(Numbers 20:7-12)

*There has never been another prophet in Israel like Moses, whom the L*ORD* knew face to face.*

(Deuteronomy 34:10 NLT)

Reflect

As our kids were growing up we basically had two household rules:

1. Be Honest.
2. Show Respect.

If one of these two rules were broken, that initiated an "event." Now an "event" in our home was rare but notable when it happened. Basically, it sent the offender into lockdown. There were no video, no toys, no friends, no television, and no playtime. As they got older, there were no phone, no parties, no car, no outings. It was memorable. We simply did not play around with dishonesty and disrespect.

For everything else, we kept it simple. Curfew depended on where they were going and who they were with. Chores depended on what needed to be done and who needed help. We wanted them to do the right thing because it was the right thing, not because of a rule. And overall, they did. Occasionally, they'd mess up. Not an "event" kind of mess up, just "kids being kids" stuff. In those cases, there were logical consequences.

If homework didn't get done, then they couldn't go out to play.

When toys didn't get picked up, no friends could come over.

If they were slow to help around the house, there was no afternoon snack.

Major violations, such as lying, required a major response. (And I think, that only happened once or twice with each kid.) Minor responses, on the other hand, just got a minor consequence. We wanted them to learn that all behaviors have consequences.

We also wanted them to know that even when they messed up, even if it was a big mess up, we loved them. There was nothing they could ever do to keep us from loving them and showing up for them.

What were some of the household rules when you were growing up?

What were the consequences for the times when you messed up?

Moses is certainly one of the greatest heroes of the Old Testament. His leadership saved millions from slavery and allowed the descendants of those millions to be born into freedom. But he was not without imperfections. His life and his character had messy moments.

For instance, early this week we saw that Moses was a man with a temper. Not only did he commit murder, he then tried to hide his actions. We also have seen this week that when God invited Moses into partnership through the miraculous encounter at the burning bush, he gave one excuse after another as to why God should choose someone else. Yesterday we noted that our messy hero was prone to discouragement and self-pity. Today, we're going to add one more thing to the list. At times, Moses was disobedient.

Perhaps the most famous example of this is found in Numbers 20:7-12, the second time God made water come from a rock. But before we explore what happened, let's back up to the first time God brought water from a rock. Let me set the scene for you.

The Israelites were traveling through the desert. I've been to the area where Moses and the Israelites would have traveled. It is hot and sandy, and there are very few natural water sources. Life without water, especially in the desert, is brutal. So, as they traveled, water was an issue. The people became thirsty. So, they did what we humans so often do. They complained. And Moses took their need before the Lord.

Reread Exodus 17:6 (page 69). What did God instruct Moses to do?

God told Moses that he was to strike a rock and water would gush forth. And it did. What a practical miracle! Later in their travels, the same need arose—water. That makes sense because they were still in the desert. So, Moses again went before the Lord and presented the need.

Look again at Numbers 20:7-12 (page 69). What is different about God's instructions to Moses this time (see v. 8)?

This time God told Moses to *speak* to the rock and water would gush forth. What happened next is where the problem comes in.

Look closely at Numbers 20:11 (page 69). What subtle error does Moses make?

Why do you think this is a problem of significance?

Moses did not obey God's instructions. Instead, he did what he had done successfully before. In most situations that would make sense. But in this case, God had given new instructions. Instead of heeding God's words, Moses relied on his own reasoning and past experience. That may not sound like a big deal, but it boils down to disobedience, which also demonstrates a lack of respect. Remember our two house rules?

When have *you* heard God speak to you but then proceeded to do things your own way? What was the outcome?

As close as Moses was to God—and they were very close, as Scripture makes clear—his disobedience had consequences, as all disobedience does. Did God stop loving Moses? Absolutely not! Did his disobedience negate all the good he had done? No way! But it did mean that Moses would experience consequences for his choice to do things his own way.

According to Numbers 20:12 (page 69), what was the consequence for Moses's disobedience?

After leading the people all the way to the Promised Land, Moses himself was not allowed to enter. God allowed him to see it from a distance, but his journey would end before they entered the land.

There are consequences when we do things our way instead of God's way. I wonder what consequences I have lived through that wouldn't have happened if I had been quicker to trust and obey. So much of the Christian journey comes down to that—trust and obey!

Moses had messes along the way, but his life was a masterpiece of truly biblical proportions. As we saw on Day 1, Deuteronomy 34:10 (NLT) says of him, "There has never been another prophet in Israel like Moses, whom the Lord knew face to face."

Well done, Moses! Well done!

Pray

Lord, please forgive me for the messes I have made and the times I have been disobedient and disrespectful to You. Like Moses, I want to learn to follow You without excuse. Help me to manage the times I am angry and discouraged. Help me to trust and obey You in all things. May my life be a shining example of how a messy person can become a faithful disciple. I love You, Lord. Amen.

> **There are consequences when we do things our way instead of God's way.**

Video Viewer Guide: Week 2

Excuse 1: I'm not _____ _____.

"Who am I that I should go to Pharaoh?"

 (Exodus 3:11)

When I don't feel good enough, I need to remember that God is _____ than _____.

Excuse 2: I don't have all the _____.

When God speaks into your life, you don't have to understand _____ to obey _____.

If you wait for perfect conditions, you will never get anything done.

 (Ecclesiastes 11:4 TLB)

Excuse 3: I don't want to be _____.

"What if they do not believe me or listen to me and say, 'The LORD did not appear to you'?"

 (Exodus 4:1)

No matter what you do in life, you will have _____. Go do _____ _____ anyway!

Excuse 4: I'm not _____.

Moses said to the LORD, "Pardon your servant, Lord. I have never been eloquent. . . . I am slow of speech and tongue."

(Exodus 4:10)

When God invites you into partnership with Him, He knows your _____.

"My grace is sufficient for you, for my power is made perfect in weakness."

(2 Corinthians 12:9)

Excuse 5: I just _____ _____ to.

"Please send someone else."

(Exodus 4:13)

WEEK 3

Elijah

Balancing Faith and Emotion

1 Kings 16–19

Memory Verse:

*"Have I not commanded you? Be strong and courageous. Do not be afraid; do not be discouraged, for the L*ORD *your God will be with you wherever you go."*

(Joshua 1:9)

DAY 1

Settle

Try something new today. Take a walk with the Lord before you get started, or go outside to read this devotional lesson. Allow your senses to be stirred so that it is easier to give God your full attention.

Focus

²⁹*In the thirty-eighth year of Asa king of Judah, Ahab son of Omri became king of Israel, and he reigned in Samaria over Israel twenty-two years.* ³⁰*Ahab son of Omri did more evil in the eyes of the LORD than any of those before him.* ³¹*He not only considered it trivial to commit the sins of Jeroboam son of Nebat, but he also married Jezebel daughter of Ethbaal king of the Sidonians, and began to serve Baal and worship him.* ³²*He set up an altar for Baal in the temple of Baal that he built in Samaria.* ³³*Ahab also made an Asherah pole and did more to arouse the anger of the LORD, the God of Israel, than did all the kings of Israel before him.*

(1 Kings 16:29-33)

Now Elijah the Tishbite, from Tishbe in Gilead, said to Ahab, "As the LORD, the God of Israel, lives, whom I serve, there will be neither dew nor rain in the next few years except at my word."

(1 Kings 17:1)

²*The famine had become very severe in Samaria.* ³*So Ahab summoned Obadiah, who was in charge of the palace. (Obadiah was a devoted follower of the LORD.* ⁴*Once when Jezebel had tried to kill all the LORD's prophets, Obadiah had hidden 100 of them in two caves. He put fifty prophets in each cave and supplied them with food and water.)* ⁵*Ahab said to Obadiah, "We must check every spring and valley in the land to see if we can find enough grass to save at least some of my horses and mules."* ⁶*So they divided the land between them. Ahab went one way by himself, and Obadiah went another way by himself.*

⁷*As Obadiah was walking along, he suddenly saw Elijah coming toward him. Obadiah recognized him at once and bowed low to the ground before him. "Is it really you, my lord Elijah?" he asked.*

⁸*"Yes, it is," Elijah replied. "Now go and tell your master, 'Elijah is here.'"*

⁹*"Oh, sir," Obadiah protested, "what harm have I done to you that you are sending me to my death at the hands of Ahab?* ¹⁰*For I swear by the LORD your God that the king has searched every nation and kingdom on earth from end to end to find you. And each time he was told, 'Elijah isn't here,' King Ahab forced the king of that nation to swear to the truth of his claim.* ¹¹*And now you say, 'Go and tell your*

In a culture defined by wickedness and idolatry, Elijah stood as a man of courage, holiness, and uncompromising faith.

master, "Elijah is here.'" [12]But as soon as I leave you, the Spirit of the LORD will carry you away to who knows where. When Ahab comes and cannot find you, he will kill me.

(1 Kings 18:2b-12a NLT)

Reflect

This week our focus is on Elijah, one of the greatest spiritual heroes of the Old Testament. In a culture defined by wickedness and idolatry, he stood as a man of courage, holiness, and uncompromising faith.

But before we dig into the life of the prophet Elijah, let's talk about the king who was reigning over Israel at the time. His name was Ahab—but not the Ahab who hunted the whale. (That would be Captain Ahab of *Moby Dick*. I couldn't resist!) This was the really bad Ahab who married the equally evil Jezebel. Under his leadership, alongside his wicked wife, the people of Israel turned away from God and were worshipping false gods and practicing all types of immorality. Ahab and Jezebel weren't just passive bystanders, watching their nation decline morally. They took an active part in bringing about and encouraged the decay of the nation they had been trusted to lead by building shrines to pagan gods, encouraging idolatry, and having the prophets of God killed.

Reread 1 Kings 16:29-33 (page 77). According to verse 30, who was King Ahab more evil than?

What does verse 33 tell us about how God responded to all that Ahab did?

It's in this environment of wickedness that God raised up a prophet to restore His people into right relationship with Himself. The man He chose to use was Elijah. The Scriptures do not give us much of his back story. We don't know how he grew up or who his mentors were. He simply appears on the scene in 1 Kings 17.

Look again at 1 Kings 17:1 (page 77). What are we told about Elijah?

What did Elijah prophesy?

Elijah was a Tishbite from Tishbe in Gilead. After that simple introduction, the action begins. Elijah confronts King Ahab and boldly makes one of the great prophecies of the Old Testament. Elijah said it, and it happened: there was no rain in Israel for over three years.

As we saw last week with Moses, water was, and still is, a valued and rare commodity in the deserts of the Middle East. So, for them to hear that God would not allow rain for three years was a devastating proclamation. God wanted to get the attention of the nation. No rain, resulting in drought and famine, did the trick. But it also had a consequence for Elijah.

Reread 1 Kings 18:2b-12a (pages 77–78). Who was Obadiah, and how had he defended God's prophets from Queen Jezebel?

What did Obadiah tell Elijah in verses 10-12?

The king was searching everywhere to find Elijah. We might say Elijah had a target on his back. And Obadiah, who had hidden one hundred prophets in caves to protect them from the wicked Jezebel, knew his life would be in danger if it were known he had seen the elusive prophet but was not able to deliver him.

Not only did Elijah need safety from the drought, he needed protection from Ahab and Jezebel's wrath. This is why, after Elijah made the great drought proclamation, God immediately told him to flee to safety. God protected Elijah at every turn and, in his timing, Elijah and Ahab came face-to-face and

had one of the greatest showdowns of Scripture. But we'll get to that later this week.

When has a difficult situation forced you to focus more completely on God and His standards?

What was the outcome?

What I invite you to do now is take the time to read the five chapters of Scripture that paint the picture of Elijah's life and legacy (see the exercise below). This will lay the foundation for where our study will take us this week. There are many timeless truths in Elijah's story—things God was trying to teach the people then that He is still trying to teach us today!

Read 1 Kings 17–19 and 2 Kings 1–2 and look for these major themes, making notes below as you read:

Trusting God to provide for needs

Confronting evil practices courageously

Practicing the power of prayer

Passing on a legacy of faith

What initial thoughts do you have after reading Elijah's story?

Elijah's life was a roller coaster. He experienced incredible highs and debilitating lows. He performed miracles. He stood for God in powerful ways in a culture consumed with wickedness. Elijah experienced firsthand God's care in the details of his life. But he also struggled with depression and even suicidal thoughts.

Elijah was a messy person. Yet, through faith, courage, and his dependence on the Lord, he persevered; and he is hailed as one of the greatest figures in Scripture.

As you study Elijah's life this week, remember that the goal is not only to become familiar with the story of Elijah but also to learn the timeless truths revealed through his life and then apply them in your own. Keep in mind the lessons outlined above: trusting God to provide, confronting evil, the power of prayer, our need to rest and recharge, and the importance of passing on our faith to the next generation. As you study this week, ask God to reveal to you how you can live out these truths in your situation.

Pray

God, give me wisdom as I study Your word to see new insights and to apply those learnings in my life. Spur me on to holiness. Give me a desire to surrender every part of my life to Your control. Amen.

DAY 2

Settle

Listen to something that brings you peace as you quiet your heart today. It may be the birds in your yard, a worship song of your choosing, or the voices of children playing near you. As you listen, ask God to give you a stillness and joy as you open up His word and focus on Him today.

Focus

²Then the word of the Lᴏʀᴅ came to Elijah: ³"Leave here, turn eastward and hide in the Kerith Ravine, east of the Jordan. ⁴You will drink from the brook, and I have directed the ravens to supply you with food there."

⁵So he did what the Lᴏʀᴅ had told him. He went to the Kerith Ravine, east of the Jordan, and stayed there. ⁶The ravens brought him bread and meat in the morning and bread and meat in the evening, and he drank from the brook.

⁷Some time later the brook dried up because there had been no rain in the land. ⁸Then the word of the Lᴏʀᴅ came to him: ⁹"Go at once to Zarephath in the region of Sidon and stay there. I have directed a widow there to supply you with food." ¹⁰So he went to Zarephath. When he came to the town gate, a widow was there gathering sticks. He called to her and asked, "Would you bring me a little water in a jar so I may have a drink?" ¹¹As she was going to get it, he called, "And bring me, please, a piece of bread."

¹²"As surely as the Lᴏʀᴅ your God lives," she replied, "I don't have any bread— only a handful of flour in a jar and a little olive oil in a jug. I am gathering a few sticks to take home and make a meal for myself and my son, that we may eat it—and die."

¹³Elijah said to her, "Don't be afraid. Go home and do as you have said. But first make a small loaf of bread for me from what you have and bring it to me, and then make something for yourself and your son. ¹⁴For this is what the Lᴏʀᴅ, the God of Israel, says: 'The jar of flour will not be used up and the jug of oil will not run dry until the day the Lᴏʀᴅ sends rain on the land.'"

[15]*She went away and did as Elijah had told her. So there was food every day for Elijah and for the woman and her family.* [16]*For the jar of flour was not used up and the jug of oil did not run dry, in keeping with the word of the L*ORD *spoken by Elijah.*

(1 Kings 17:2-16)

[8]*"For my thoughts are not your thoughts,*
 neither are your ways my ways,"
 *declares the L*ORD.
[9]*"As the heavens are higher than the earth,*
 so are my ways higher than your ways
 and my thoughts than your thoughts."
 (Isaiah 55:8-9)

"Even the very hairs of your head are all numbered."
 (Matthew 10:30)

Reflect

On the night when each of my children was born, once the nurses had gone and everything had settled down, I took them into my arms and examined every little part of them. For hours I studied their tiny fingers and toes, their eyes and ears, and their beautiful skin and lips. Even their delicate nails were fascinating to me. There was no part of them I was not interested in knowing about. There was nothing I wouldn't do to protect and care for these tiny new people in my life.

God is the same way toward us.

Look at Matthew 10:30 (above). What does God know about you?

If God is interested in that, how much more interested must He be in what is going on in your heart and the troubles you are facing? Sit with this thought for a moment and write your response below:

Throughout Scripture, God does things in ways that may seem unconventional to us.

God is a God of the details!

After the prophet Elijah made the bold proclamation that there would be no rain for three years, God sent him into hiding. Why? Because God was aware that the message Elijah delivered would bring him consequences. Ahab began to search for him, and we can be confident his intentions were not honorable. So, God gave Elijah a plan.

Yet, as is so often the case, God's plan was an unusual one. Throughout Scripture, God does things in ways that may seem unconventional to us. For instance, He made man from dust and woman from a rib (Genesis 2). He spoke to Moses through flaming shrubbery (Exodus 3). He made an ax head float (2 Kings 6). And He brought His Son into the world through a virgin (Luke 1–2). God's way of doing things is often unexpected—and sometimes quite spectacular.

Look again at 1 Kings 17:2-16 (pages 82–83). What did God instruct Elijah to do?

Elijah was told to turn eastward and hide in a ravine. Once there, water was provided through a brook, and bread and meat were brought to him by birds each morning and evening. What an elaborate and unexpected way to provide for the practical needs of this man of God.

As the drought continued, God continued to look after Elijah's practical needs by sending him to Zarephath, where he met a widow. She, too, needed help. In God's divine way, He cared not only for Elijah but also brought a blessing into the life of the woman who opened her home to Elijah.

How do you think the widow of Zarephath's faith was impacted by what God did after Elijah's arrival?

The God who knows every hair on your head also knows every need in your life. Part of maturing in our faith is learning to trust that.

Reread Isaiah 55:8-9 (page 83). What important insight regarding the way God works do we find in these verses?

God's ways are not only unusual, they also are often beyond our understanding. Yet even when we don't understand what God is up to, we can be confident that He is working on our behalf. That can give us the courage to step out in faith like Elijah did!

When has God called *you* to do something scary, although you weren't sure what He was up to? How did you respond?

When my husband, Jim, and I felt called to start a new church back in 1999, there were a lot of unknowns. Where would we go? Would it work? Who would help us? How quickly could we sell our house and move to the new area? There were so many questions and so many concerns. But we decided to go for it, knowing that God would handle the details.

We put our home on the market and began to look for a new one about an hour away, in the area we had been assigned, which was Middle Georgia. Jim began to commute. We found a home we loved and hoped to buy, but our current home just sat on the market. Month after month we waited. Then two amazing things happened. First, our pastor from the old church came to us and said someone had put money in an account to pay our current mortgage until our home sold. He said a family felt that God told them to do that to help us begin our new ministry. But we didn't feel comfortable accepting it; it was just too much. Plus, without selling our home, we couldn't afford to buy a new one. So, Jim continued to commute.

Then a second amazing thing happened. The owners of the home we loved called us and said that God had told them that we were the ones who were supposed to buy their house. Then they said that if we couldn't afford it now, they would move out and we could just pay their mortgage until our situation changed. We asked them what they would do in the meantime, and they said, "We'll just move into an apartment. God wants you here, and we want to help. So, just take the blessing."

It was hard to accept what was being offered, but when we realized God had orchestrated the whole thing, it was even harder to say no to His blessings. God had handled everything. There was a plan for the old home and for the new one. We went from being uncomfortable accepting help to being afraid not to. If God had gone to the trouble to line up all of these details, who were we to be too stubborn to receive His blessings.

It was ten long months before we sold our original home. Ten months of being both humbled and grateful. On the day we closed on our old home, the new couple buying it said, "This house was waiting just for us. It's going to be such a blessing!"

God was in every step of the plan—ours and theirs! To this day we don't know who the couple was that put the money into that account to cover the mortgage, but I can tell you this—God blessed them for their obedience. I'm sure of it and I'm thankful for it!

Look back carefully at your life. Where can you see God's fingerprints, showing you He was at work?

God will call on you to be brave at times too. When He does, remember that God is with you.

Elijah trusted that God was with him, and that trust gave him the courage to step out in faith and deliver the hard prophecy God had for Israel. But God did not abandon Elijah after he delivered that message. He was with him, anticipating Elijah's needs and caring for him in practical ways.

God will call on you to be brave at times too. When He does, remember that God is with you. He knows your needs and will not abandon you. Let that be encouragement to trust God so that, like Elijah, you can be bold for God too!

Pray

Thank You, God, for the way You love and care for me. For all the ways You've been there for me in the past, I thank You. Today I lay my cares before You and ask that You help me trust You even more. Like Elijah, I want to be brave and courageous. Amen.

DAY 3

Settle

Spend time reading and meditating on the following verses, prayerfully considering what they convey about God's love for you:

"The LORD will fight for you; you need only to be still."

> (Exodus 14:14)

"Have I not commanded you? Be strong and courageous. Do not be afraid; do not be discouraged, for the LORD your God will be with you wherever you go."

> (Joshua 1:9)

God raised us up with Christ and seated us with him in the heavenly realms in Christ Jesus.

> (Ephesians 2:6)

Focus

[1]After a long time, in the third year, the word of the LORD came to Elijah: "Go and present yourself to Ahab, and I will send rain on the land." [2]So Elijah went to present himself to Ahab.

> (1 Kings 18:1-2)

[20]Ahab sent word throughout all Israel and assembled the prophets on Mount Carmel. [21]Elijah went before the people and said, "How long will you waver between two opinions? If the LORD is God, follow him; but if Baal is God, follow him."

But the people said nothing.

[22]Then Elijah said to them, "I am the only one of the LORD's prophets left, but Baal has four hundred and fifty prophets. [23]Get two bulls for us. Let Baal's prophets choose one for themselves, and let them cut it into pieces and put it on the wood but not set fire to it. I will prepare the other bull and put it on the wood but not set fire to it. [24]Then you call on the name of your god, and I will call on the name of the LORD. The god who answers by fire—he is God."

Then all the people said, "What you say is good."

²⁵Elijah said to the prophets of Baal, "Choose one of the bulls and prepare it first, since there are so many of you. Call on the name of your god, but do not light the fire." ²⁶So they took the bull given them and prepared it.

Then they called upon the name of Baal from morning till noon. "Baal, answer us!" But there was no response; no one answered. And they danced around the altar they had made.

²⁷At noon Elijah began to taunt them. "Shout louder!" he said. "Surely he is a god! Perhaps he is deep in thought, or busy, or traveling. Maybe he is sleeping and must be awakened." ²⁸So they shouted louder and slashed themselves with swords and spears, as was their custom, until their blood flowed. ²⁹Midday passed, and they continued their frantic prophesying until the time for the evening sacrifice. But there was no response, no one answered, no one paid attention.

(1 Kings 18:20-29)

³³"Fill four large jars with water and pour it on the offering and on the wood."

³⁴"Do it again," he said, and they did it again.

"Do it a third time," he ordered, and they did it the third time. ³⁵The water ran down around the altar and even filled the trench.

³⁶At the time of sacrifice, the prophet Elijah stepped forward and prayed: "Lord, the God of Abraham, Isaac and Israel, let it be known today that you are God in Israel and that I am your servant and have done all these things at your command. ³⁷Answer me, Lord, answer me, so these people will know that you, Lord, are God, and that you are turning their hearts back again."

³⁸Then the fire of the Lord fell and burned up the sacrifice, the wood, the stones and the soil, and also licked up the water in the trench.

³⁹When all the people saw this, they fell prostrate and cried, "The Lord—he is God! The Lord—he is God!"

(1 Kings 18:33b-39)

For God gave us a spirit not of fear but of power and love and self-control.

(2 Timothy 1:7 ESV)

Reflect

In high school I had a particularly tough teacher. Not tough in grading, as some can be, but tough emotionally. His method of correction was to call

out a student and then publicly humiliate them. Once or twice it was aimed at me, and it was traumatic. But on a more regular basis, it was aimed at one or two of my classmates who struggled to keep up. Those moments left deep impressions on my young heart.

To make things worse, I didn't have this instructor just once but all four years of high school. The way he would single out a student and then just pick at them until they broke gave me nightmares all through college and into young adulthood.

Finally, in my thirties—yes in my thirties—I decided I had to deal with these painful memories. As I reflected on the dreams that haunted me, I realized they were never about him picking on me. They were about me sitting and watching the torture of a classmate and not standing up and saying anything! The nightmares were a result of my shame.

While I sat in that class and watched this month after month, year after year, I often felt God telling me to speak up. It was clear that someone needed to make this stop. It was wrong. But I did nothing. My fear was crippling. My goal in that class was to keep my head down and hope his wrath came my way as seldom as possible.

As a young teenager, I just didn't have the wisdom to know what to do, and I certainly did not have the courage to stand up to a teacher. The shame from that fear and my lack of action ran deep for many years. There were so many nightmares involving that particular classroom!

Then I took it to God. I needed forgiveness—from God, from myself, and, I hoped, from the students I failed to defend (though I couldn't even remember their names). As I did the work to get through those nightmares, I felt a deep sense of justice rising up in me. Looking back, I think that sense of seeking justice had always been there. The difference now was that I couldn't tolerate the idea of being the one who just stood by again, afraid to speak up for what was right.

When have you felt God prompting you to speak up for those who can't or won't speak up for themselves?

How did you respond?

What issues do you see in our culture that Christians should be making a stand for today? List them below. Circle one that especially tugs at your heart.

As we have seen, Elijah was born into a world consumed with idolatry and all types of sinful behavior. It was clear that the people of Israel, under the leadership of Ahab and Jezebel, had turned away from God and were completely controlled by their sinful desires. It was Elijah who finally had the courage to confront Ahab with the declaration of God's judgment (1 Kings 17:1-2).

Reread 1 Kings 18:1-2 (page 87). We aren't told what transpired between God's word to Elijah and Elijah's obedient response. What thoughts and feelings do you imagine Elijah might have had? What would your own conversation with God have sounded like?

After Elijah confronted Ahab, God directed Elijah to spend three years avoiding Ahab's search and waiting out the famine. As we saw in yesterday's lesson, God's miraculous care through a brook, ravens carrying bread, and a widow's miraculous never-ending source of oil sustained Elijah and emboldened him so that he was ready when God called him once again to confront Ahab.

Refer to 1 Kings 18:20-26, 33-39 (pages 87–88), and write your own description of what happened on Mount Carmel as if writing for your local newspaper. Have fun with it!

In one of the most famous showdowns of the Bible, God told Elijah to go head-to-head with 450 prophets of Baal at Mount Carmel. Elijah challenged the false prophets to call on their god to bring down fire from heaven and burn up the sacrifice that had been laid out. They chanted. They danced. They slashed themselves and screamed. But their god did not respond.

We're told that Elijah mocked them. He even went so far as to suggest that maybe Baal was on a trip or had gone to the bathroom. That was pretty bold sarcasm from a guy so outnumbered!

But, of course, Baal did not answer. The prophets were defeated. And all the while, the people of Israel were watching.

When Elijah's turn came, he had the altar doused with water repeatedly. He had a trough created around the sacrifice to hold all the extra water. Then Elijah called on the one true God to respond.

Immediately fire from heaven struck, burning up everything, including the water in the trough. God won. And the people of Israel, once more, turned their hearts to the Lord.

Unlike the high school version of myself, Elijah did not shirk away from doing what was right. In fact, he didn't appear to be afraid. Instead, he approached evil straight on with a sense of authority and power.

After spending three years in hiding, what do you think fueled Elijah's bold spirit?

Where do you sense God calling *you* to be bold right now?

Are any fears holding you back? If so, name them below.

Were you able to identify what fears hold you back? Maybe it's the fear of failure. Most of us have that one to some degree. Maybe it's a fear that what God is asking you to do has too high a cost. Maybe your fear is that God will take you out of your comfort zone. (He specializes in that one.)

Most of us deal with fears in different areas of our lives. That's natural. But it can be a huge problem when those fears keep us from doing what our heavenly Father is calling us to do. That's why we need to identify them and then begin to deal with them.

Once we've identified what is holding us back from boldly speaking up for truth and God's principles, we can ask God for the courage to move past our fear. As 2 Timothy 1:7 (ESV) says, "God gave us a spirit not of fear but of power and love and self-control."

Write a prayer in the margin, asking God for the courage to move past your fear:

Remember, God is not the source of your fear. He is the power, the love, and the courage you need to move forward despite your fears. Stay close to Him so that when He needs someone to stand for truth, you will do what Elijah did—stand!

Pray

- Lay your fears before the Lord today. Write them down. Pray about them. Ask God to give you the power to defeat them. Then wad them up and throw them away.
- You may want to listen to a song about how God fights for us, like Shane & Shane's song "You've Already Won."

DAY 4

Settle

What troubles are you carrying today? Write them down and then examine them. Present them to the Lord and ask Him for help in discerning where He is at work in each situation. Ask Him to give you wisdom in how to deal with each struggle. Then talk with God about them. Once you've prayed, set them aside and focus your attention on God alone.

Focus

Read 1 Kings 18:16-46 and all of 1 Kings 19.

40Then Elijah commanded them, "Seize the prophets of Baal. Don't let anyone get away!" They seized them, and Elijah had them brought down to the Kishon Valley and slaughtered there.

41Then Elijah said to Ahab, "Go, eat and drink, for there is the sound of a heavy rain."42So Ahab went off to eat and drink, but Elijah climbed to the top of Carmel, bent down to the ground and put his face between his knees.

43"Go and look out toward the sea," he told his servant. And he went up and looked.

"There is nothing there," he said.

Seven times Elijah said, "Go back."

44The seventh time the servant reported, "A cloud as small as a man's hand is rising from the sea.

"So Elijah said, "Go and tell Ahab, 'Hitch up your chariot and go down before the rain stops you.'"

45Meanwhile, the sky grew black with clouds, for the wind rose, a heavy rain started falling and Ahab rode off to Jezreel. 46The power of the LORD came on Elijah and, tucking his cloak into his belt, he ran ahead of Ahab all the way to Jezreel.

<div align="right">(1 Kings 18:40-46)</div>

1Now Ahab told Jezebel everything Elijah had done and how he had killed all the prophets with the sword. 2So Jezebel sent a messenger to Elijah to say, "May the gods deal with me, be it ever so severely, if by this time tomorrow I do not make your life like that of one of them."

³Elijah was afraid and ran for his life. When he came to Beersheba in Judah, he left his servant there, ⁴while he himself went a day's journey into the wilderness. He came to a broom bush, sat down under it and prayed that he might die. "I have had enough, LORD," he said. "Take my life; I am no better than my ancestors."

(1 Kings 19:1-4)

⁹And the word of the LORD came to him: "What are you doing here, Elijah?"

¹⁰He replied, "I have been very zealous or the LORD God Almighty. The Israelites have rejected your covenant, torn down your altars, and put your prophets to death with the sword. I am the only one left, and now they are trying to kill me too."

(1 Kings 19:9-10)

"The human heart is the most deceitful of all things."

(Jeremiah 17:9a NLT)

Reflect

The showdown at Mount Carmel was a pinnacle of Elijah's ministry. It was a stellar moment. The miracle was tremendous. God's power was witnessed and God's presence was felt. The nation once again turned back to God. And Elijah had the privilege of being the one to partner with God to make it all happen. What a moment that must have been for him!

Elijah stood for his beliefs, trusted the Lord, and made a stand—alone. He confronted the king and the 450 prophets of Baal—and won! When God answered in fire and burned up the offering, it must have been the most powerful moment of Elijah's ministry career.

Reread 1 Kings 18:40-46 (page 93) and answer the questions below:

What did Elijah do immediately after this bold display of God's power? (v. 40)

What were Elijah's instructions to King Ahab? (v. 41)

What did Elijah do next, and what was his posture? (v. 42)

How many times did Elijah send his servant to look for a rain cloud? How did Elijah display his faith when his servant reported a tiny cloud rising from the sea? (vv. 43-44)

Elijah told King Ahab to prepare a feast, eat, and then head home because rain was finally coming—and when it would come, it would come hard. Elijah believed rain was coming, yet still he prayed. He climbed to the top of Mount Carmel to pray, watch, and wait.

Meanwhile, Ahab did exactly what Elijah told him to do. In chapter 19 we see that he returned home to his wife, Jezebel, and relayed to her all that had happened, including the slaughter of her precious Baal prophets. Despite the fact that God had revealed Himself at the altar on Mount Carmel, and despite the return of the rain, Jezebel was enraged at the death of her false prophets. So, she sentenced Elijah to death.

What an emotionally exhausting day this must have been for God's prophet! He had faced off with the false prophets, called on God, watched a mighty miracle, prayed in faith for rain, and then started off on a journey to outrun the rain and a death squad. It's not surprising that what we see next is Elijah at a breaking point.

Reread 1 Kings 19:1-4 (pages 93-94). What do we learn about Elijah in these verses? What can we infer about his condition mentally, emotionally, physically, and spiritually?

What is Elijah's plea in verse 4?

⁵Then he lay down under the bush and fell asleep.

All at once an angel touched him and said, "Get up and eat." ⁶He looked around, and there by his head was some bread baked over hot coals, and a jar of water. He ate and drank and then lay down again.

*⁷The angel of the L*ORD *came back a second time and touched him and said, "Get up and eat, for the journey is too much for you."*

(1 Kings 19:5-7)

Read 1 Kings 19:5-7 in the margin. How did God respond to Elijah's plea?

Elijah was alone and afraid. As he fled into the desert and reached Beersheba, his exhaustion caught up with him. Completely depleted, Elijah called out to God to go ahead and end his life. This is a low moment for sure!

I want to pause here to highlight how valuable for us it is that the Bible doesn't paint the heroes of the faith in only a bright light. We need truth, and the truth is that the heroes of Scripture were human and struggled in the same ways we do. Jacob, Leah, and Rachel struggled with envy, conflict, deceit, and selfishness. Moses was filled with insecurity and excuses. In Elijah we see emotional and physical turmoil expressed in fatigue, discouragement, and even suicidal thoughts.

What are some of your own struggles? Circle the three difficult emotions below that seem to be present most often in your life:

Depression	Insecurity	Lust	Fear
Loneliness	Envy	Irritability	Worry
Worthlessness	Anger	Shame	Anxiety
Discouragement	Greed	Hatred	Apathy
Hopelessness	Despair	Self-loathing	Guilt

How do you tend to deal with these emotions?

Some healthy ways to respond to hard emotions might include the behaviors listed below. Circle those that have helped or might help you.

Praying	Going to the gym	Journaling
Taking a walk	Listening to music	Reading the Bible
Counseling	Talking with a friend	

On the other hand, there are many unhealthy ways to deal with difficult emotions that can lead to unhealthy outcomes. Are any of these go-to coping mechanisms in your life?

Medicating	Drinking Alcohol	Experiencing Anger
Isolating	Blaming	Manipulating Others
Overworking	Emotional Eating	Other _____

Elijah had reached his emotional limit. He had moved from just feeling sad to actually wishing his life might end. Sometimes when we feel discouraged, a snack and a nap will revive us. But when those feelings run so deep that we lean toward suicidal or self-harming thoughts, we need professional help and intervention. The National Suicide Prevention Lifeline, 1-800-273-TALK, and the Suicide and Crisis Lifeline, 988, are available if you or someone you know needs that care.

Elijah was alone in the wilderness. There was no 1-800 number to call. In his exhaustion, Elijah fell asleep. Then, miraculously, an angel woke him and offered him food and water. He ate and then took another nap. My husband, Jim, likes to say that in our emotional desperation, it is good to know that sometimes a viable answer may be to have a snack and take a nap! And even when we need more serious help, food and rest are always a good start.

According to 1 Kings 19:8, where did Elijah go after he was rested and refueled, and how long did it take him to get there?

Elijah left Beersheba and headed to Mount Sinai, the mountain of God, which is about 260 miles away. This was no short or easy journey—and likely would have been impossible without the food and rest God had provided. When he arrived, he was no doubt physically tired—and, apparently, still struggling emotionally and spiritually.

Read 1 Kings 19:11-14. What did Elijah experience on the mountain, and how did he hear from God?

What did God ask Elijah, and how did he respond?

While he was alone in a cave, Elijah sought the Lord and wrestled with his feelings. He experienced a great wind, an earthquake, and a fire, but he did not hear from God in those moments. It was in stillness that God spoke to Elijah in a whisper, asking, "What are you doing here, Elijah?" Elijah's answer was transparent. He pled his case of serving God faithfully yet felt alone and afraid. He thought he was the only one left on earth who loved and served God. But he was mistaken.

According to 1 Kings 19:18, how many others were faithful in Israel?

We know from our reading in chapter 18 on Day 1 that because of Obadiah's faithfulness, one hundred prophets of the Lord had been hidden from wicked Jezebel. Elijah knew he was not the only remaining prophet. Yet in his isolation, he felt nothing but loneliness. We also know that God had never left Elijah. He had been present with him in mighty ways and had cared for Elijah through one miracle after another. But in his exhaustion, Elijah lost sight of that and was left with discouragement and depression. The same thing can happen to us.

Our emotions are normal human responses to life's events and are meant to be helpful guides, revealing to us inner realities that need our attention with God. Yet without the healthy and wise handling of our emotions, they can mislead us. As Jeremiah 17:9 (NLT) says, "The human heart is the most deceitful of all things." This means that apart from connection and conversation with God, our emotions can lead us to unhelpful responses, rather than to helpful ones. Our fears, anxiety, and depression can alert us to needs, concerns, wounds, or false beliefs that need to be addressed, or they can cause us to have confused thought processes that can lead us to doubt God's love, or even His presence. When you face those moments of confusion, instead of doubting God, doubt your doubts. Instead of immediately challenging God, challenge the thought processes that are plaguing you by talking to God

When you face those moments of confusion, instead of doubting God, doubt your doubts.

about them. Be honest about how you are feeling, just as Elijah did, and then trust God to care for you and lead you in the way you should go.

Like Rachel, Leah, and Moses, Elijah was a messy person. Yet through faith, courage, and his dependence on the Lord, he persevered. As a result, he is considered one of the greatest figures in Scripture. Do you remember who met Jesus at the Mount of Transfiguration? It was Elijah and Moses. That's pretty esteemed company!

There is so much to learn from Elijah's story. It is one of great faith and victory, but also one of depression and exhaustion. Both lessons are important, and both are meant to be applied in our own situations. Remember, our goal is not only to learn the stories of Scripture but also to learn the timeless truths revealed within them. May God use Elijah's story to speak into your own story!

Pray

God, my heart is often filled with _____

(write difficult emotions you often deal with here). Help me have wisdom and insight about how to handle these normal human emotions. Give me clarity in how You are guiding me to tend to my heart and soul. Help me to learn healthy ways to address fear and anxiety so I may be filled with Your peace and courage and live a life that is pleasing to You. Amen.

DAY 5

Settle

Find a place today to sit in stillness and listen for the whisper of God. You may even want to set a timer for five minutes. Eliminate the distractions, and simply call upon the Lord and listen for Him to respond to your heart's call.

Focus

¹¹*The Lord said, "Go out and stand on the mountain in the presence of the Lord, for the Lord is about to pass by."*

Then a great and powerful wind tore the mountains apart and shattered the rocks before the Lord, but the Lord was not in the wind. After the wind there was an earthquake, but the Lord was not in the earthquake. ¹²*After the earthquake came a fire, but the Lord was not in the fire. And after the fire came a gentle whisper.* ¹³*When Elijah heard it, he pulled his cloak over his face and went out and stood at the mouth of the cave.*

Then a voice said to him, "What are you doing here, Elijah?"

¹⁴*He replied, "I have been very zealous for the Lord God Almighty. The Israelites have rejected your covenant, torn down your altars, and put your prophets to death with the sword. I am the only one left, and now they are trying to kill me too."*

¹⁵*The Lord said to him, "Go back the way you came, and go to the Desert of Damascus. When you get there, anoint Hazael king over Aram.* ¹⁶*Also, anoint Jehu son of Nimshi king over Israel, and anoint Elisha son of Shaphat from Abel Meholah to succeed you as prophet.* ¹⁷*Jehu will put to death any who escape the sword of Hazael, and Elisha will put to death any who escape the sword of Jehu.* ¹⁸*Yet I reserve seven thousand in Israel—all whose knees have not bowed down to Baal and whose mouths have not kissed him."*

(1 Kings 19:11-18)

Reflect

We all need people. To the extroverts reading this, you already know this. In fact, you thrive with lots of social interaction. You're the people who are always ready for a party. And you're probably the life of those parties!

To the introverts, on the other hand, you may have read that first sentence and thought, *Nope, not me. People are exhausting.* I get it. I'm somewhere in the middle on this spectrum. In fact, I recently learned there is a name for people like me: ambivert. We ambiverts love being around people; but honestly, long exposure to humans wears us out.

None of these personalities is right or wrong. We're just created differently, and that's great because too much of any of us would be challenging. No matter where you fall on the people-fatigue scale, you still need friends. God did not create you to live in isolation. Times of solitude, peace, and quiet are restful for the soul, but isolation will leave you vulnerable. We all need people. That's how God designed us.

Are you an introvert, extrovert, or ambivert? How do you know?

When has time alone been restful to your soul? When has it led to feelings of isolation?

As we saw yesterday, the showdown at Mount Carmel was a victorious moment for Elijah. God showed up and showed out! But it left Elijah emotionally and physically exhausted. That exhaustion, coupled with the fear of being chased by Jezebel's army, also left him afraid, depressed, and desperate. He was depleted. And in that fatigue, his perception was altered. He felt alone. He wasn't, but he felt that way.

After years in isolation, Elijah forgot that Obadiah had hidden one hundred other prophets who were just waiting to engage. They were ready to resume ministry. In his exhausted state, his perception of reality was distorted—so distorted that he was ready for God to end his life.

Elijah had to get still on the mountain of the Lord and wait for the wind and the earthquake and the fire to pass so that he could hear God speak.

> **God did not create you to live in isolation. Times of solitude, peace, and quiet are restful for the soul, but isolation will leave you vulnerable. We all need people.**

When has it been hard for you to hear God speak?

What did it take for you to get to a place where you could clearly hear from God and His Word again?

In the stillness, God spoke. And the message gave Elijah purpose and people.

Reread 1 Kings 19:15-18 (page 100). What was Elijah's purpose, and who were his people?

God told Elijah to go and anoint two new kings. Elijah was then instructed to go and meet his future friend and successor, Elisha. I can't help wondering if Elijah had known what God had next for him, or known that he had friends waiting to greet him, would he not have sunk so low emotionally. God knew Elijah was not done. He still had work to do, and he was not being asked to do it alone.

We all need purpose and people. Without them we can easily slip into frustration, depression, and a distorted sense of reality. Just like Elijah.

Who is in your spiritual tribe?

If you don't have one, what steps can you take to build one with God's help?

What purpose do you sense God calling you to in this season of life? If you're unsure, write a prayer asking God to give you clarity and guidance.

As we conclude our week of learning from the life of Elijah, let's review what we've learned so we can be sure to apply these lessons in our lives:

How and on what issues is God calling you to make a stand?

What needs are you asking God to meet in your life right now?

What is your purpose in this season? Who are your spiritual people? (Summarize from page 102.)

Where do you turn when life gets hard? What would it look like for prayer to become the rock upon which your life is built?

This point in Elijah's story was not the end. If you continue reading through 1 Kings and into 2 Kings, you will see Elijah's constant faithfulness. Though Ahab and Jezebel and other evil leaders continued to promote idolatry, Elijah did not waver. And, as a reward, his life ended in a manner unlike any other—with a chariot ride straight to God's throne. What a fabulous way to get to heaven. To finish this week's study, I encourage you to read about it in 2 Kings 2—it's amazing!

Pray

- Thank God for all the ways He has been present in your life.
- Ask Him to continue surrounding you in this season with people and purpose.
- Pledge your faith to Him in loving those people and following that purpose like Elijah did.

Video Viewer Guide: Week 3

1. Faithfulness requires having the _____ to _____ evil.

2. We can trust God to _____ for our needs.

3. We have to take time to _____—physically, spiritually, mentally, and emotionally.

4. Prayer is _____.

 If you abide in me, and my words abide in you, ask whatever you wish, and it will be done for you.
 (John 15:7 ESV)

5. It's important to pass on a _____ of _____ to the next generation.

WEEK 4

Mary and Martha

Establishing Priorities

Luke 9–10

John 11–12

Memory Verse

But seek first his kingdom and his righteousness, and all these things will be given to you as well.

(Matthew 6:33)

DAY 1

Settle

Take out a pen and paper and write down a few of the most important things you have to do this week. Now, review your list. Are these *really* the most important things? Perhaps they are, but maybe not. In these few moments of stillness, consider what things will matter most at the end of the week and at the end of a lifetime. Then, make sure those are the things that get your full attention today.

Focus

[1]One day Jesus called together his twelve disciples and gave them power and authority to cast out all demons and to heal all diseases. [2]Then he sent them out to tell everyone about the Kingdom of God and to heal the sick. [3]"Take nothing for your journey," he instructed them. "Don't take a walking stick, a traveler's bag, food, money, or even a change of clothes. [4]Wherever you go, stay in the same house until you leave town. [5]And if a town refuses to welcome you, shake its dust from your feet as you leave to show that you have abandoned those people to their fate."

(Luke 9:1-5 NLT)

[51]As the time drew near for him to ascend to heaven, Jesus resolutely set out for Jerusalem. [52]He sent messengers ahead to a Samaritan village to prepare for his arrival. [53]But the people of the village did not welcome Jesus. . . .

[58]Jesus replied, "Foxes have dens to live in, and birds have nests, but the Son of Man has no place even to lay his head."

(Luke 9:51-53a, 58 NLT)

[5]"Whenever you enter someone's home, first say, 'May God's peace be on this house.' [6]If those who live there are peaceful, the blessing will stand; if they are not, the blessing will return to you. [7]Don't move around from home to home. Stay in one place, eating and drinking what they provide. Don't hesitate to accept hospitality, because those who work deserve their pay.

[8]"If you enter a town and it welcomes you, eat whatever is set before you. [9]Heal the sick, and tell them, 'The Kingdom of God is near you now.' [10]But if a town refuses to welcome you, go out into its streets and say, [11]'We wipe even the dust of your town from our feet to show that we have abandoned you to your fate. And know this—the Kingdom of God is near!' [12]I assure you, even wicked Sodom will be better off than such a town on judgment day."

(Luke 10:5-12 NLT)

As Jesus and the disciples continued on their way to Jerusalem, they came to a certain village where a woman named Martha welcomed him into her home.

(*Luke* 10:38 NLT)

Reflect

This week we are transitioning from a few of the Old Testament's messy but amazing people to some from the New Testament. We started our Old Testament journey with sisters Leah and Rachel. So, it's fitting that we start our New Testament journey with another set of sisters. This week our focus is Martha and Mary, the sisters of Lazarus.

Before we get into their story, let me set the scene for you. Turn to Luke 8 and 9. Jesus's ministry was in full swing. These chapters recount incredible teachings and miracles, such as the parable of the sower, the lampstand, and the good Samaritan. They tell of the feeding of the five thousand, the calming of the storm, raising a child to life, and healing a woman who was bold enough to reach out and touch the hem of Jesus's cloak. They also contain the account of the Transfiguration and the sending out of the disciples to heal and preach with authority. These are power-packed chapters, describing a power-packed time of ministry.

However, it's in these verses, and others like them, that we see a subtle transition from Jesus being welcomed into communities to an increasingly hostile attitude toward Him. With each passing miracle and every sermon, the Pharisees grew more irritated. They were threatened by what Jesus taught and by His popularity with the people. So, their plans to silence Him intensified. And that opposition became well known throughout Israel.

The plots against Jesus began to greatly affect how he and his disciples were greeted as they traveled. For example, earlier in his ministry Jesus waited for a woman by Jacob's well in Samaria. As word of his presence spread on the first visit, the Samaritans insisted he stay with them a few days. They extended gracious hospitality, a deeply ingrained principle of Middle Eastern life. As a result, that first visit brought precious life change. John 4:41 says, "Because of his words many more [Samaritans] became believers."

But in Luke 9:53, when Jesus prepared to go back to Samaria, the welcome committee did not roll out the red carpet. The atmosphere had changed. The Samaritans didn't want trouble with the Romans or the Pharisees. So, when Jesus sent a messenger ahead to prepare for His visit, we read that "the people [of the village] did not welcome [Jesus]."

Read that again: "the people [of the village] did not welcome [Jesus]." The community that had once welcomed Him with open arms had shut their doors to Jesus and His disciples.

Have you ever felt unwelcome? What were the circumstances, and how did it make you feel?

Read Matthew 13:58 in the margin. Based on what this verse tells us, what were the consequences for a town, family, or person who did not welcome Jesus in faith?

And he did not do many miracles there because of their lack of faith.
Matthew 13:58

Jesus was not surprised by the changing attitudes he and his followers experienced. He knew it was coming. He had even been preparing his disciples for this turn of events.

Reread Luke 9:5, 58 and 10:5-12 (page 107). What did Jesus tell His disciples to prepare them for an unwelcome response?

Jesus, the Son of God, who took on human form to prepare a way for humankind to be reconciled with their Creator, was unwelcome among the people of His own creation. What must that have felt like? If I were Jesus— and, of course, I'm not—I would be hurt and a little ticked off. I'd be thinking, *Let me get this straight. I just fed five thousand people, shared parables, did amazing miracles, came here to help you, and you won't even let us stay here?*

But I'm not Jesus, and anger is not what we see in Him here. Rather, we see determination. Perhaps he was hurt. Maybe he was sad. But whatever human emotions he was experiencing, he kept moving forward.

Welcome or not, the decision had been made. There was more to be done. So, Jesus and his disciples left the safety of the Galilee region and headed south.

Look back at Luke 9:51 (page 107). What word is used to describe how Jesus set out for Jerusalem?

The adverb *resolutely* tells us Jesus had made up His mind. The time had come. He knew what God wanted him to do; and although it was excruciating, he was determined to do it. There was no escaping what lay ahead in Jerusalem.

It's after this time of rejection and lack of hospitality that our famous siblings come into the picture. They offered just what Jesus needed: friendship and accommodation.

According to Luke 10:38 (page 108), what kind of reception did Jesus receive from Martha?

Jesus knew what lay ahead. He needed a safe place to rest and call home, and he found that in the small town of Bethany, just two miles east of Jerusalem. This was where Martha, Mary, and their brother, Lazarus, lived. And it was in the walls of their home where Jesus and His disciples were welcomed.

After being rejected in Samaria and facing opposition from the Pharisees, Martha welcomed Jesus. And he didn't come alone. He brought the gang. Housing and feeding thirteen men, and those who may have been traveling with them, would have been a task! Still, Martha was quick to invite them into their home.

Do you tend to be quick to offer your home or resources to others? If not, what holds you back?

My son played high school football, and on several occasions after practice he brought his buddies home. They were a rough, sweaty, and always hungry group of guys. But I learned quickly that if I loved on them and had pizza bites ready, they'd stick around and hang out. Creating a welcoming environment was easy in this case. All I had to do was be friendly and offer them food. But now that I think about it, that's what I do with my friends as well. It doesn't have to be complicated to create a welcoming atmosphere.

Can you recall a time when someone made you feel welcome and special? What did they do to create that environment?

How can you help create a welcoming environment...

 in your home?

 in your church?

 in your Bible Study?

This week we will dig into the lives of Martha and Mary. We'll navigate through the tension of serving and learning, as well as the grief and faith they experienced at their brother's death. But for today, I want you to pause and ponder the incredible gift of hospitality.

When we help people feel welcome, when we go out of our way to meet the practical needs of others, it is powerful. What Martha did for Jesus that day surely was like medicine for His soul. He was welcome. There was a place to rest and refresh. Good for you, Martha! May we be quick to do the same.

Pray

Lord, may it never be true of me that You are unwelcome in my life, my schedule, or my home. I invite You in. Let's sit and visit a while. You are welcome, Jesus! Amen.

When we help people feel welcome, when we go out of our way to meet the practical needs of others, it is powerful.

DAY 2

Settle

Like a hostess prepares her home for guests, spend a few moments preparing your heart and mind for a special time with Jesus. Clear out the clutter and create a welcoming environment as you give Jesus your full attention.

Focus

"Be still, and know that I am God;
 I will be exalted among the nations,
 I will be exalted in the earth."
 (Psalm 46:10)

[38]As Jesus and his disciples were on their way, he came to a village where a woman named Martha opened her home to him. [39]She had a sister called Mary, who sat at the Lord's feet listening to what he said. [40]But Martha was distracted by all the preparations that had to be made. She came to him and asked, "Lord, don't you care that my sister has left me to do the work by myself? Tell her to help me!"

[41]"Martha, Martha," the Lord answered, "you are worried and upset about many things, [42]but few things are needed—or indeed only one. Mary has chosen what is better, and it will not be taken away from her."

(Luke 10:38-42)

Reflect

Jim and I recently had a guest stay with us for about a week. He is a delightful person and truly one of the finest people we've ever known. But, the dude can eat! Three, sometimes four, or even five meals a day was his norm. Now, this was a challenge because, in general, I don't cook. Like at all. So, keeping him fed and being a good hostess took a lot out of me. On his last night with us, at about 8:30 p.m., he asked, very politely, if there would be another hot meal for the day. *Friend, I'm heading to bed in twenty minutes*, I thought. But instead of escaping to my bedroom, I scrounged through the refrigerator and put together a sandwich, which I heated up! Voilà, a hot meal. Sort of.

As someone who doesn't cook much, the role of hostess can take a toll. So, when I think about Martha inviting Jesus *and* the disciples—and the women who traveled with them—into her home, it overwhelms me. That's a lot of people. And I'm guessing those fishermen were hearty eaters!

Martha probably cordially welcomed them in and then began making a list. How many blankets would they need? Was there food enough to go around? Should she send someone to the market? So much to do! Martha got busy.

As we saw yesterday, we have to give Martha credit for the initial invitation of hospitality. But the Scriptures are clear that once her guests arrived, she became consumed by the tasks she felt needed to be done.

Reread Luke 10:40 (page 112). What had distracted Martha?

In the English Standard Version of the Bible, Luke 10:40 says, "Martha was distracted with much serving." Other translations say she was worried, upset, and anxious over all that needed to be done. I relate deeply to that verse!

I, too, am often distracted with much serving. I'll even be vulnerable enough to admit that, like Martha, at times I have been so busy serving that I resented those who were not busy doing the same. This has been true in my home and in my church. When the work becomes overwhelming, my attitude sometimes plummets and relationships suffer.

When have you become so involved in serving that it negatively affected your relationship with God or others?

Martha's serving had become a distraction to the main event. Jesus was in the house, and she was missing it. So, she went to Jesus.

Look again at Luke 10:40 (page 112). What did Martha say to Jesus? What do you hear in her choice of words?

Martha confronted Jesus with what sounds like a fussy complaint—"Lord, *don't you care that my sister has left me to do the work by myself? Tell her to help me!*" And Jesus gently corrected her.

Reread Jesus's reply in Luke 10:41-42 (page 112). What does it say to you that Jesus repeated her name twice?

I like the fact that Jesus said her name twice, "*Martha, Martha.*" I picture him looking her right in the eyes and, instead of returning her intensity, calling her by name and basically saying, "*Quit worrying and come and sit with me.*"

I hear it as a sweet invitation to lay down her burdens, relax, and choose the greater thing: *him.* Jesus was literally a guest in her house, but the details of the day kept Martha from enjoying his presence. Mary, on the other hand, took full advantage. She claimed a front-row seat, and Jesus commended her for her choice.

In verse 42, how does Jesus describe Mary's choice?

> We want to be like Mary, but we end up like Martha—well-intentioned but drowning in self-appointed, or maybe even other-appointed, tasks. And it leaves us overwhelmed—maybe even resentful.

Jesus said Mary chose what was *better.* Other translations say "the good part" (NASB) or "one thing worth being concerned about" (TLB). Part of me thinks, *Way to go, Mary, way to prioritize. Way to make the wise choice.* But another part of me, the part that prepared that hot sandwich at 8:30 p.m., is thinking, *Come on, Mary! Get up and help a sister out!*

Most women I know relate to Martha. We want to be Mary and put everything aside and just sit at the feet of Jesus, but we're busy. So busy that our priorities often become skewed. We want to be like Mary, but we end up like Martha—well-intentioned but drowning in self-appointed, or maybe even other-appointed, tasks. And it leaves us overwhelmed—maybe even resentful.

How does being overwhelmed affect you?

How does it affect those around you?

What can you do differently the next time you feel overwhelmed to be sure it doesn't negatively affect your relationship with Jesus or those around you?

Martha dealt with her frustration by taking it straight to Jesus. That was a good first step, even if it was done with a bad attitude. However, His response probably was not what she expected. I'm guessing Martha hoped Jesus would reprimand Mary, or maybe even send a few disciples to the kitchen to help out. Instead, he corrected her. That must have been a shock. She was drowning in responsibility and, instead of sympathy, she got correction, because her priorities were askew. Jesus pointed out that she had chosen poorly when she didn't choose him first.

Tomorrow we look at finding balance between being still before the Lord and handling the responsibilities on our to-do lists. But for today, let's slow down and choose wisely by spending some time at the feet of Jesus.

Pray

- Make Psalm 46:10 your action step and prayer today.
- Pray: *Dear God, help me to be still and know you. Help me identify and then eliminate things that distract me from being in your presence.*
- Now, simply open your heart to Jesus and allow Him to speak to you.

DAY 3

Settle

As you quiet your heart today, jot down a few notes about what matters to you. Don't overthink it. Just write down what you would like your priorities to be. You may want a peek at my list to get you started:

- my relationship with God,
- my husband,
- my kids and their families,
- our parents, and
- friends, extended family, and work.

Write yours here:

Now examine your list. Is this how you devote your time? Is anything out of order? Spend a few moments consulting your Creator about what He wants on your list and how you're doing with priorities.

Focus

Teach me your way, Lord,
* that I may rely on your faithfulness;*
give me an undivided heart,
* that I may fear your name.*

 (Psalm 86:11)

"But seek first his [God's] kingdom and his righteousness, and all these things will be given to you as well."

 (Matthew 6:33)

28*"Come to me, all you who are weary and burdened, and I will give you rest.*
29*Take my yoke upon you and learn from me, for I am gentle and humble in heart, and you will find rest for your souls.* 30*For my yoke is easy and my burden is light."*

(Matthew 11:28-30)

38*As Jesus and his disciples were on their way, he came to a village where a woman named Martha opened her home to him.* 39*She had a sister called Mary, who sat at the Lord's feet listening to what he said.* 40*But Martha was distracted by all the preparations that had to be made. She came to him and asked, "Lord, don't you care that my sister has left me to do the work by myself? Tell her to help me!"*

41*"Martha, Martha," the Lord answered, "you are worried and upset about many things,* 42*but few things are needed—or indeed only one. Mary has chosen what is better, and it will not be taken away from her."*

(Luke 10:38-42)

Reflect

Holidays of my childhood were split between my grandparents' homes. My dad's family lived on the east coast of Georgia, my mom's in the middle of the state. So, like many families, we jumped from house to house. There was lots of traveling back and forth. It was our regular thing. A lot of my childhood was spent in those homes with cousins, aunts, uncles, and, of course, our precious grandparents.

But it's odd that when I think back on those many celebrations, I have so few memories of my grandmothers. I know they were there. They'd hug me when I walked in the door, and I'd see them at the adult table during meal time. But beyond that, there just aren't many memories. I've often wondered why that is.

Then one day it came to me. Their time was spent in the kitchen. With so many mouths to feed, they were busy preparing to feed a small army. And the food really was great! But it came at a cost. That cost was in relationships.

Now that my grandmothers are no longer with me, I regret that there were so few meaningful times spent together. I wish we had laughed more, played more, really anything that brought us closer, even if it was cooking. (Maybe if I'd been in there with them, I'd enjoy cooking more today? Probably not, but who knows!)

How can I have a heart like Mary while being productive like Martha?

I've thought about this a lot recently, because I have just joined the grandma club! So many of you told me it would be awesome being a granny, and you were right! It's the best! My precious grandson, Jordi James, is now just a few months old. So, I often think about the relationship I hope to have with him. In fact, he and I recently had an in-depth conversation. I did most of the talking since he's just three months old. I explained to Jordi that I am not interested in being a visitor in his story. I want to be a major character! Therefore, he can expect many fun adventures and lots of time spent together with his Jenny.

When Jordi thinks back, I want there to be lots of great memories to choose from! But I also work full time, live eight hours away from him, and have more responsibilities on a daily basis than I'd really like to have. So, I've been asking myself, *how can I have a heart like Mary while being productive like Martha*? I think the answer will come through balance and choosing my priorities intentionally.

In order to say yes to the best things in my life, I may have to say maybe later, or even no, to some of the good things. Saying no to the bad things is easy. It's saying no to the good things that is hard. As I mentioned in our Settle time today, I have made it my goal to prioritize, in order to enjoy the best of this life.

Would those closest to you describe you more as a Martha or a Mary? Why?

What relationships suffer in the busyness of your life?

How does the pace of your life affect your relationship with Jesus?

Look again at Matthew 6:33 (page 116). What did Jesus tell us to seek first, and what did he say would be the outcome?

Jesus said, "Seek first [God's] kingdom and his righteousness, and all these things will be given to you as well." This verse clearly tells us how to schedule our lives. First, seek Jesus. Then, all the rest. First is always Jesus; then everything else.

But let's be honest. We live in a world where a Martha-style work ethic is often expected. In fact, usually it's the person who is being productive, staying on top of things, and getting the work done who is admired and rewarded—or at the very least, appreciated.

Review Luke 10:38-42 (page 117) once more. Based on this account, what would you list as Mary's priorities?

Martha, as hostess, wanted to get stuff done. There were mouths to feed—a lot of them. Like my grandmothers, Martha saw the needs in front of her and got to work. That seems like a noble task. So, when I see Jesus gently scold Martha for being busy and praise Mary for sitting with Him, it gives me pause. What am I missing?

Did Martha mess up her priorities? If she had just taken a seat like Mary, what would they have done for food? Weren't they hungry? Were there enough blankets for the night? What about the details? *Jesus, what about the details?*

He probably chuckles at that type of question and thinks, *I had just fed five thousand men, plus all the women and children, from one kid's lunch box* [see Luke 9:10-17]. *Surely, we can figure out dinner for twenty. Relax and enjoy being with me. Sit down and hang out with me like Mary is.* Jesus was all over the details. That is why we can take the time to relax and enjoy His presence. "Seek first," remember? Then all the other things will come into focus.

Practically speaking, what does it mean to seek Jesus first in our lives?

It's important to note that Mary was not being lazy in this passage. She was not intentionally shirking work. She was "seeking first." She had prioritized her time. She is an example of someone who made a choice to put Jesus first. She put spending quality time with Jesus above the demands of the world, and Jesus commended her for it—even when those around her didn't understand and criticized her. She chose well.

Have you ever been criticized, or criticized someone else, for prioritizing Jesus—for seeking God and His kingdom first? If so, write about it briefly.

The demands of the world—or should I say, the perceived demands—can be overwhelming. That's why Jesus clearly tells us that we have to stay close to God and be sure that His priorities are our priorities. Friend, I don't know about you, but I sometimes put together my own to-do list without consulting Jesus. My list can get long, and sometimes I resent the workload. That's when I remind myself of Jesus's beautiful invitation and promise at the end of Matthew 11.

Read Matthew 11:28-30 again (page 117). Who does Jesus invite to come to him?

What does he promise?

How does Jesus describe his yoke and burden?

Jesus invites *all* who are weary and burdened. He says his yoke is easy and his burden is light! But the burdens I sometimes create, or allow to be created for me, are often heavy and unbearable. It's in these overwhelming moments that I become discouraged. Like Martha, I become distracted, worried, and upset.

As we saw yesterday, Martha was not just busy. She was consumed with details that could wait. The tasks before her kept her from enjoying the presence of Christ in her home.

What keeps you distracted, worried, and upset?

What keeps you from enjoying the presence of Christ daily?

Read Psalm 86:11 below, and circle the words *undivided heart*.

Teach me your way, Lord,
 that I may rely on your faithfulness;
give me an undivided heart,
 that I may fear your name.

> ## Jesus invites *all* who are weary and burdened.

> **An undivided heart can focus. It can prioritize. It helps you say yes and gives you courage to say no to what would distract you from God's presence.**

An undivided heart can focus. It can prioritize. It helps you say yes and gives you courage to say no to what would distract you from God's presence—even if those distractions could be good and productive.

As I think about developing my relationship with Jordi, I realize I want him to know that he can have my full attention anytime he needs it. He is a priority. For me to do that, I am going to have to be intentional about my schedules and to-do lists. It's worth it. That little guy is worth it.

That's what God wants from you and me. God says our relationship with Him is worth it. He wants us to do what Mary did. To sit with Him. To reprioritize our schedules in order to just sit and soak in the presence of our Savior. Let's get proactive, friends, and find the balance of living like Mary in a Martha-driven world.

Pray

Dear Jesus, help me to slow my pace and seek You first. In all I do, I want our relationship to be my top priority. When I get off track, please gently nudge me back. When I get distracted, please forgive me as You did with Martha. Call my name, maybe even twice, to bring me back to Your presence, Jesus. Amen.

DAY 4

Settle

As you quiet your heart before the Lord today, listen to a song that brings you peace—perhaps a hymn from your childhood or a favorite chorus. Sing or hum along and allow God's Spirit to envelop you.

Focus

[38]As Jesus and his disciples were on their way, he came to a village where a woman named Martha opened her home to him. [39]She had a sister called Mary, who sat at the Lord's feet listening to what he said. [40]But Martha was distracted by all the preparations that had to be made. She came to him and asked, "Lord, don't you care that my sister has left me to do the work by myself? Tell her to help me!"

[41]"Martha, Martha," the Lord answered, "you are worried and upset about many things, [42]but few things are needed—or indeed only one. Mary has chosen what is better, and it will not be taken away from her."

(Luke 10:38-42)

[1]Now a man named Lazarus was sick. He was from Bethany, the village of Mary and her sister Martha. [2](This Mary, whose brother Lazarus now lay sick, was the same one who poured perfume on the Lord and wiped his feet with her hair.) [3]So the sisters sent word to Jesus, "Lord, the one you love is sick...."

[32]When Mary reached the place where Jesus was and saw him, she fell at his feet and said, "Lord, if you had been here, my brother would not have died."

(John 11:1-3, 32)

[1]Six days before the Passover, Jesus came to Bethany, where Lazarus lived, whom Jesus had raised from the dead. [2]Here a dinner was given in Jesus' honor. Martha served, while Lazarus was among those reclining at the table with him. [3]Then Mary took about a pint of pure nard, an expensive perfume; she poured it on Jesus' feet and wiped his feet with her hair. And the house was filled with the fragrance of the perfume.

[4]But one of his disciples, Judas Iscariot, who was later to betray him, objected, [5]"Why wasn't this perfume sold and the money given to the poor? It was worth a

year's wages." *He did not say this because he cared about the poor but because he was a thief; as keeper of the money bag, he used to help himself to what was put into it.

*"Leave her alone," Jesus replied. "It was intended that she should save this perfume for the day of my burial. *You will always have the poor among you, but you will not always have me."

(John 12:1-8)

Reflect

During the summers when I was a kid my mom implemented what she called "quiet time" every day after lunch. Here's how it was supposed to work. We would play all morning, have lunch, and then my brothers and I were sent to our rooms for an hour to "enjoy" some "quiet time." We could read, sit quietly, or nap. But we had to stay in our rooms and be quiet.

My younger brother, Matt, obliged. He would grab a book and lie in his bed like a little angel and read quietly. Sometimes he would even stay there when the hour was over! What a weirdo. But for me, that quiet time was brutal. Ten-year-old me sitting quietly for an hour? I just couldn't do it! It was summer! There was stuff to do! We lived in the country, and my best friend wasn't far away. Why would I stay inside, quietly, when there were places to explore and games to play? All summer I suffered with this torture my mom called "quiet time."

As an adult, I realize my mom probably just needed a few moments of peace as a mother of three little kids. She probably also hoped that an hour spent quietly would be educational. (I think it actually was for my brothers.) Reading for ten minutes I probably could have handled, but an hour? It just wasn't in me at that age. I love you, Mom, but it was brutal!

If Mary and Martha had been at my house that summer, I think Mary would have enjoyed "quiet time," like my brothers did. Martha, on the other hand, probably would have been like me, just itching to get outside and get going.

For some of us, finding peace and enjoying moments of stillness, like Mary, come naturally. For others, we relate more to Martha. Busyness helps us feel alive. It may even be that we find a sense of worth in being productive. After all, the world rewards productivity. We may fall into the trap that so

many do, which says the more I accomplish, the more value I have. But that thinking isn't from God at all. Our worth does not come from what we do but from who God is and who He says we are as members of His family.

We are His children. Chosen, forgiven, and valued! What Jesus most values is not our productivity but our devotion. Mary understood this.

We read about Mary three times in Scripture. First in Luke 10, at her home in Bethany, then in John 11 at Lazarus's death, and then in John 12, at a dinner given in Jesus's honor.

Reread Luke 10:38-39 (page 123). Where was Mary and what was she doing?

Now reread John 11:1-3, 32 (page 123). What posture do we see Mary taking in verse 32?

Finally, review John 12:1-8 (pages 123-124). According to verse 3, where was Mary positioned once again?

In each of these encounters we find Mary at the feet of Jesus. Mary found her place at the feet of her Savior.

In the Luke passage, she was doing what few women of the time would have been allowed to do. She was seated with the men who were listening and learning. She was being discipled. In John 11 she fell to His feet in her grief, and then in John 12 she washed and anointed Jesus's feet using her hair as a drying towel.

How do we see others responding to Mary's choice to be at the feet of Jesus in the Luke 10 and John 12 passages? Describe their responses to her below.

> **Our worth does not come from what we do but from who God is and who He says we are as members of His family.**

How does Jesus respond?

In these two scenarios, Mary is criticized. And in both situations, Jesus defends her. Mary chose Jesus, and she was rewarded with His approval. It's interesting that Mary's reaction to the criticism isn't recorded.

How do you think Mary responded to the criticism? Imagine yourself in her place, sitting at the feet of Jesus, your Savior. Would you be concerned about what others thought or said? Explain your response.

I like to imagine that the criticism didn't bother Mary in the least. After all, what does the criticism of others matter when you have the approval of Jesus?

Take another look at Luke 10:41-42 (page 123). As you consider Jesus's reaction to Mary and Martha, what message does he have for *you*?

Do you tend to be more like Mary or Martha? That's not really a fair question because, the truth is, we're meant to be both. There is a place for both serving and worshipping. The trick is to find the balance. And as I've

said, in a world that rewards productivity, it is easy to slide toward the role of Martha.

As someone who has worked in the church for decades, I tend to relate more closely to Martha. I have spent years being busy and productive. But in my productivity, there have been times when I was not present with the One I was serving. Sometimes, especially on busy days, a certain verse runs through my mind.

Look up John 12:8 and complete the verse below:

"You will always have the _____ among you, but you

will not always have _____."

(John 12:8)

I think the Holy Spirit brings this to mind to tell me, "There is always work to be done, Jen, but slow down and spend time with Me." I think that was Jesus's message to Martha, and it is His message to me on many days. I'm a busy, active girl, but what I long to be is like Mary, seated at the feet of Jesus, learning and worshipping. I want to find my worth not in what I have done or am doing, but simply in who Jesus is in my life. I want the peace and focus that Mary had. And I want the approval from God's Son that she received.

To receive that approval, we simply have to give all of our attention to Him—to slow down and sit at His feet. What Jesus wants is *you*—all of you! He wants *your whole face*. Let me explain what I mean.

> **What Jesus wants is *you*— all of you!**

When our daughter was about three years old, she was talking to my husband while he was reading. She was telling a story about her day, and he was half listening. She finally reached up, took his face in her little hands, and turned it toward her and said, "Daddy, I need your whole face."

That saying stuck around our home. When we really want each other's undivided attention we'll say, "I need your whole face." That interaction helped me learn this important life lesson:

I can **choose** *to slow down and give what matters, and who matters, my full attention.*

Notice the word *choose* is in bold. It is a choice to slow down and prioritize, as we saw in yesterday's lesson. Mary chose Jesus. She chose to give Him her whole face.

How do you feel when someone gives you their undivided attention?

Who needs your whole face today? How can you give it to them?

How can you be more intentional in giving Jesus your whole face?

Seek [God] first, and everything else will fall into place.

Mary wasn't lazy. It wasn't that she was just trying to get out of work while her sister slaved away. She prioritized. And in doing so, she found favor repeatedly in the eyes of her Savior.

Finding balance in today's world can be challenging. The demands are real, but so are God's commands. Seek first God. That's it. Seek Him first, and everything else will fall into place. Friends, let's make that a lifelong goal!

Pray

Lord, help me have a desire to seek You first every day. I want to intentionally sit at Your feet, soaking in Your presence. Please forgive me when the demands of this world overwhelm me and I get things out of balance. I want to give You my whole face. Amen.

DAY 5

Settle

As you quiet your heart to spend some sweet time with the Lord today, listen to Bethel Music's song "You Came (Lazarus)." The lyrics are sung from Lazarus's point of view. But as you listen, make the words your own. He came not just for Lazarus, but also for you.

"I'm not afraid, I see Your face."

Focus

3So the sisters sent word to Jesus, "Lord, the one you love is sick. . . ."

5Now Jesus loved Martha and her sister and Lazarus.

(John 11:3, 5)

17On his arrival, Jesus found that Lazarus had already been in the tomb for four days. 18Now Bethany was less than two miles from Jerusalem, 19and many Jews had come to Martha and Mary to comfort them in the loss of their brother. 20When Martha heard that Jesus was coming, she went out to meet him, but Mary stayed at home.

21"Lord," Martha said to Jesus, "if you had been here, my brother would not have died. 22But I know that even now God will give you whatever you ask."

23Jesus said to her, "Your brother will rise again."

24Martha answered, "I know he will rise again in the resurrection at the last day."

25Jesus said to her, "I am the resurrection and the life. The one who believes in me will live, even though they die; 26and whoever lives by believing in me will never die. Do you believe this?"

27"Yes, Lord," she replied, "I believe that you are the Messiah, the Son of God, who is to come into the world."

(John 11:17-27)

32When Mary reached the place where Jesus was and saw him, she fell at his feet and said, "Lord, if you had been here, my brother would not have died."

³³When Jesus saw her weeping, and the Jews who had come along with her also weeping, he was deeply moved in spirit and troubled. ³⁴"Where have you laid him?" he asked.

"Come and see, Lord," they replied.

³⁵Jesus wept.

³⁶Then the Jews said, "See how he loved him!"

(John 11:32-36)

⁴⁰Then Jesus said, "Did I not tell you that if you believe, you will see the glory of God?"

⁴¹So they took away the stone. Then Jesus looked up and said, "Father, I thank you that you have heard me ⁴²I knew that you always hear me, but I said this for the benefit of the people standing here, that they may believe that you sent me."

⁴³When he had said this, Jesus called in a loud voice, "Lazarus, come out!" ⁴⁴The dead man came out, his hands and feet wrapped with strips of linen, and a cloth around his face.

(John 11:40-44)

⁹Meanwhile a large crowd of Jews found out that Jesus was there and came, not only because of him but also to see Lazarus, whom he had raised from the dead. ¹⁰So the chief priests made plans to kill Lazarus as well, ¹¹for on account of him many of the Jews were going over to Jesus and believing in him.

(John 12:9-11)

Reflect

Though we've focused our attention on Martha and Mary this week, Lazarus is also an important player in their story—and in the gospel story. As we bring the week to a close, we will surely come away with two of the most familiar points from their story: (1) Martha and Mary teach us about priorities, and (2) Lazarus was raised from the dead (as we've just read in our Scripture Focus). Those are important points! But if we look more deeply, we will discover some other key truths contained here. Today we'll look at a few of those takeaways and consider what they might mean for us.

1. Martha, Mary, and Lazarus enjoyed a close friendship with Jesus.

Jesus *loved* this brother and his sisters! They were close friends. We don't want to miss the sweetness of their relationships. Martha didn't get everything right, but Jesus loved her. Mary was overcome with grief after her brother's death and didn't come out to meet Jesus right away, but he loved her. Lazarus got sick and died, but Jesus loved him. He loved them all. In fact, as we read their story in Luke 10, it almost reads as if they are family.

Turn to Luke 10:38-42 (page 123) and review this familiar scene.
What clues do you find that suggest their relationships were close?

Martha speaks freely to Jesus, complaining about her sister. Jesus speaks directly to Martha with tenderness, telling her Mary has chosen the better part. Their interactions are casual and direct as might be expected among family members. Likewise, their home appears to have been a safe haven from the pressures Jesus faced in the world.

We find another clue to the intimacy of their relationships when the sisters sent word to Jesus that Lazarus was ill.

Complete John 11:3 below:

"Lord, the _____ _____ _____ is sick."

The sisters didn't say, "Our brother needs help." They said, "Lord, *the one you love* is sick." This was a precious way of alerting Jesus to their needs. They knew and embraced the love Jesus had for them and their brother. *The one you love is sick.* In these few words we hear the friendship, the emotion, the intimacy of their relationship. They knew how deeply Jesus loved them, and they loved him in return.

In fact, if I could go back in time and observe a single biblical moment, I just might choose being in this home in Bethany when Jesus and the siblings were gathered, like we see in Luke 10. I imagine I'd experience laughter, hearty meals, deep teaching, and a casual but intimate friendship that would help me understand more clearly the heart of Jesus. Yes, the resurrection of Christ

or His birth would be cool moments too, but this home in Bethany—well, I think it was pretty special.

If you could go back in time and encounter Jesus, what moment would you choose and why?

If you could be an observer in one of the scenes we've explored this week in the lives of Martha, Mary, and Lazarus, which would you choose and why?

2. Martha, Mary, and Lazarus knew Jesus as Lord and Savior.

In addition to knowing Jesus as a dear friend, these three siblings knew Jesus as much more—their Lord and Savior. When Jesus arrived in Bethany to comfort the grieving sisters, certainly this was an emotionally charged moment. We read that Jesus Himself wept. But in this time of sadness, Jesus clearly stated who He is and what He had come to do.

Glance again at John 11:17-27 (page 129).

What do you hear in Martha's words as she talked with Jesus after her brother had died?

Who did Jesus say He is, and what had He come to do for those who believe in Him?

The theology here is rich and clear—the one who puts their faith in Jesus, even though they die, will live. Then Jesus makes it personal.

What did Jesus ask Martha next, and how did she respond? (vv. 26-27)

Jesus asked Martha if she believed what he had said, to which—even in her sadness—she quickly responded, "Yes, Lord, I believe that you are the Messiah, the Son of God, who is to come into the world." Martha may not have sat with Mary at the feet of Jesus, but there is no doubt that she knew who Jesus was! She believed he was the Messiah, and she professed her belief quickly and confidently.

Review John 12:1-8 in yesterday's lesson (pages 123–124). What did Mary's actions suggest about how she viewed Jesus? How was this an extravagant act of worship?

Now reread John 12:9-11 (page 130). What was happening because Jesus had raised Lazarus from the grave? According to verse 11, why were the chief priests feeling threatened?

Do you think the one whom Jesus raised from the dead, and on whose account many Jews were believing in Jesus, also believed that Jesus was the Messiah? Circle your response.

I don't know Seems probable I'm confident Lazarus believed

Martha, Mary, and Lazarus had a personal relationship with Jesus, and their story suggests that their personal relationship went beyond friendship to Lordship for all three. They were not only friends; they were his brother and sisters in faith.

What about *you*? How would you describe your relationship with Jesus? Have you made John 11:25-26 personal? If so, when did you decide to follow Jesus as Lord? If not, what is holding you back?

3. Martha, Mary, and Lazarus were available for Jesus's purposes.

The home of Martha, Mary, and Lazarus in Bethany was a safe haven for Jesus, but their service to Jesus went beyond that. Let's look at the siblings and their contributions in ministry one by one.

Martha: The hostess, the doer, the leader

Martha sprang into action to care for the needs of others. Yes, she famously got her priorities out of order from time to time. But let's not give her too hard of a time, because she also was quick to serve and care for those around her. She provided Jesus and His followers a home when they needed one. We can do the same today by welcoming others into our homes, into our groups, and into our churches. We can also serve like Martha by providing for practical needs in the way of food, shelter, and clothing.

Mary: The learner, the disciple, the worshipper

There are many Marys in Scripture, but this Mary is best known for her time spent at the feet of Jesus. Whether it was falling before him in grief or being seated at his feet to learn or even to anoint his feet before his death, Mary was ready to learn and to serve through devoted worship. Having a heart like Mary today often reveals itself in being eager to study, learn, and worship. We are still to be productive; worship is not an excuse not to serve.

It's not a matter of either/or but of both/and. We are to have hearts to worship *and* hands to serve. Both!

Lazarus: The friend, the comrade, the example

When Jesus called Lazarus out of the grave, it was a turning point in Jesus's life and ministry. A dead man walking was more than the Pharisees could stomach, so they plotted to kill Jesus. But their plot didn't end there. Having a miracle man, Lazarus, walking around town led many people to believe in Jesus. So, the Pharisees plotted to kill Lazarus too. Lazarus was a living, breathing example of the power of God through Christ. We, too, are called to be living, breathing examples of the power of God on a daily basis by sharing in word and action with those around us.

Martha, Mary, and Lazarus followed Jesus's call. They each found ways to serve him and to live into purposes.

What purposes do you feel Jesus calling you to? How is Jesus calling you to serve?

Because Martha, Mary, and Lazarus knew Jesus as both friend and Savior, they were available to be used for His purposes. But they also were human. I'm so glad that the Bible doesn't paint them as perfect. We need to see their humanity. Martha struggled with distraction. Mary was overcome with grief. Lazarus died of sickness. This is real-world stuff! Yet, Jesus was with them through it all. And we can count on Him to be with us through it all too.

As the lyrics of the song "You Came (Lazarus)" (recommended in the Settle portion of today's lesson) remind us, Jesus comes to us in our troubles. He is faithful and true. He always comes! Thank You, Lord! Thank You that we can call You Savior, Friend, Rescuer, and Redeemer!

Pray

Lord, I want what Martha, Mary, and Lazarus experienced with You—a relationship built on love and trust. Help me to know You and to understand that You have chosen me. I want our relationship to be close and intimate. Amen.

> We are to have hearts to worship *and* hands to serve.

[38] As Jesus and his disciples were on their way, he came to a village where a woman named Martha opened her home to him. [39] She had a sister called Mary, who sat at the Lord's feet listening to what he said. [40] But Martha was distracted by all the preparations that had to be made. She came to him and asked, "Lord, don't you care that my sister has left me to do the work by myself? Tell her to help me!"

[41] "Martha, Martha," the Lord answered, "you are worried and upset about many things, [42] but few things are needed—or indeed only one. Mary has chosen what is better, and it will not be taken away from her."

(Luke 10:38-42)

1. Write down your _____.

"Seek first his Kingdom and his righteousness, and all these things will be given to you as well."
(Matthew 6:33 CJB)

2. Ask God to give you a _____ to honor Him.

Schedule a _____ and a _____ to meet with Jesus daily.

Put the _____ aside.

Keep a _____ close.

Learn what to say _____ to.

Find some _____ you can talk to about what you are learning.

WEEK 5

Peter

Growing Up into Christ

Matthew 14; 16; 18

Luke 5; 22

John 18; 21

Acts 2; 10

Memory Verse

So all of us who have had that veil removed can see and reflect the glory of the Lord. And the Lord—who is the Spirit—makes us more and more like him as we are changed into his glorious image.

(2 Corinthians 3:18 NLT)

DAY 1

Settle

Consider who Jesus is in your life today: Friend, Savior, Lord, Example, Hope, Redeemer—and on the list goes.

Choose three words that best describe how you are experiencing His presence in this season:

_____ _____ _____

Focus

You will seek me and find me when you seek me with all your heart.
<div align="right">(Jeremiah 29:13)</div>

[1]One day as Jesus was standing by the Lake of Gennesaret, the people were crowding around him and listening to the word of God. [2]He saw at the water's edge two boats, left there by the fishermen, who were washing their nets. [3]He got into one of the boats, the one belonging to Simon, and asked him to put out a little from shore. Then he sat down and taught the people from the boat.

[4]When he had finished speaking, he said to Simon, "Put out into deep water, and let down the nets for a catch."

[5]Simon answered, "Master, we've worked hard all night and haven't caught anything. But because you say so, I will let down the nets."

[6]When they had done so, they caught such a large number of fish that their nets began to break. [7]So they signaled their partners in the other boat to come and help them, and they came and filled both boats so full that they began to sink.

[8]When Simon Peter saw this, he fell at Jesus' knees and said, "Go away from me, Lord; I am a sinful man!" [9]For he and all his companions were astonished at the catch of fish they had taken, [10]and so were James and John, the sons of Zebedee, Simon's partners.

Then Jesus said to Simon, "Don't be afraid; from now on you will fish for people." [11]So they pulled their boats up on shore, left everything and followed him.

<div align="right">(Luke 5:1-11)</div>

Reflect

Time in the car with my children when they were little proved to be one the best settings for us to have great conversations. Often as I strapped them into their car seats I would think of a question that would get their little minds churning and get a conversation started. I'd turn off the music, shut down the video player, and just try to get them talking. I wanted to know what was on their hearts and minds. It was in this setting that Alyssa would tell me about her day. Once she asked me where babies came from. That was an interesting car ride! And it was in the car seat, at age six, that Josh announced, "Mom, I think I just know about Jesus. I'm not sure I know Him for real. But I want to." What a great discussion opener from a first grader!

From that conversation, Josh began to seek Jesus for himself. He didn't just want to know the Bible stories, or hear about God from his parents and church leaders. He wanted a personal relationship. He wasn't looking for a historical figure or a great teacher. He wanted to know God for himself. So, he began, even at that young age, to seek Jesus. And as the Scriptures promise, when we seek Him with our whole hearts, we will find Him! From his searching, Josh found what he was looking for—Jesus, in an up close and personal way.

How did you come to know Jesus personally?

How do you continue to seek Jesus today?

When we first meet Simon Peter, we see that he was tired. He'd been fishing all night and had returned home with empty nets. Frustrated and exhausted, surely, he must have felt it was time for a nap. But that's not what happened next.

When we seek Him with our whole hearts, we will find Him!

Reread Luke 5:1-11 (page 139). What were the fishermen doing when Jesus got into Simon's boat at the water's edge? (v. 2)

What did Jesus ask Simon, and what did Jesus proceed to do? (v. 3)

When Jesus stepped into Simon Peter's boat and asked to use it as a pulpit, I imagine something along these lines might have passed through his mind: *Oh, come on, Teacher, I'm beat. I'm ready to go home.* But Peter didn't say that. He did as Jesus asked.

Peter seemed to understand that his boat was needed. The crowds that had gathered to hear Jesus were large. If they were going to see and hear the Teacher, then it would be helpful for him to speak from out on the water, because the surface of the water would reflect and amplify the sound. As a fisherman, Peter surely had experienced this acoustical phenomenon. So, even in his weary state, he climbed into the boat with Jesus and rowed out from shore.

What an unexpected blessing that proved to be for Peter. Not only did he have a front row seat to Jesus's seaside teaching, but, as we read, the payment for making this aqua pulpit available was greater than Peter could have imagined!

What happened after Jesus finished speaking to the crowd? Refer again to Luke 5:1-11 and complete the following prompts:

What Jesus said to Simon Peter:

Peter's reply:

What happened next:

Peter's physical and verbal response:

Jesus's reply to Peter:

Peter's action:

After Jesus finished speaking to the crowd, he turned to his new fisherman buddies and showed not only his appreciation but also his power. "Let's go out a little deeper, guys, and see if we can't get you some fish," he basically said. This was when both Peter's weariness and his skill as a fisherman kicked in. He responded, "Master, we've worked hard all night and haven't caught anything" (v. 5). Do you hear the hint of reluctance in those words? Because he was a fisherman, he probably was thinking, *I've heard you're a carpenter by trade. As a lifelong fisherman, I can tell you that the best fishing is at night. And, this crowd has surely scared away whatever fish were close by. So, can we please get that nap now?*

But Peter didn't say what he might have been thinking. Thank goodness! Instead, he showed respect for the Teacher and did as Jesus instructed. Peter was available and reluctantly obedient. And Jesus blessed him. They caught such a large number of fish that their nets began to break!

In what area(s) of your life do you sometimes think you know best and struggle to be obedient?

When have you been unexpectedly blessed by making yourself available to God despite any hesitation you might have felt?

As a fisherman, Peter knew this catch was not normal. Jesus had revealed himself to Peter in a way that he could easily understand. And Peter's reaction was extreme. He fell at Jesus's feet, repented, and called him Lord. It was a distinct change from simply knowing Jesus as just teacher. This up-close experience led Peter to know Jesus as his Lord and Savior.

Simon Peter's life changed forever after that morning on the shore of Lake Gennesaret, also known as the Sea of Galilee. The huge catch of fish was a blessing, but Simon Peter, along with several of his companions, left it all behind after coming to know Jesus. They were now disciples, following their Master.

According to Luke 5:10-11, which of Peter's companions also chose to follow Jesus?

Look up Matthew 4:18-22. In this account, who joined Peter in following Jesus?

Peter; his brother, Andrew; and James and John all left their work as fishermen to answer Jesus's call to become disciples. Many teachers in the first century, known as rabbis, had disciples. These disciples would leave their line of work to follow their rabbi closely, both literally and figuratively. Their goal was not only to learn from their teacher, whom they followed, but also to become like him. A true disciple's life goal was, and still is, to become a living copy of their rabbi.

When Peter met Jesus that day on the shore, it changed his life forever. Where and/or when did you decide to follow Jesus, and how has it changed your life?

How has following Jesus changed you *recently*?

Peter's story is our story—it's mine and it's yours. We met Jesus, Jesus loved us and called us, and our lives changed forever. For Peter, it began in a boat on the Sea of Galilee. For me, it began beside a creek when I was on a camping trip at age fourteen (more about that on Day 4 this week). For my son, Josh, it began while in a car seat strapped into a Ford Expedition. Wherever it happens, making the decision to follow Jesus is only the beginning.

From humble beginnings come mighty warriors! Peter's beginning on a beach after a tough night's work wasn't glamorous, but it was glorious. And as we'll see this week, a simple fisherman became one of the greatest disciples the world has ever known.

Friends, when we give our hearts to God, falling to our knees like Peter and making Jesus our Lord, the trajectory of our lives changes, just as it did for Peter. This is *our* story. Let's make it personal. Allow Jesus to meet you right where you are today. Give Him your attention and whatever is at your disposal. You may not be Peter, and neither am I. But when we put our hands in the hands of Jesus, there is no telling what may happen next!

> **When we put our hands in the hands of Jesus, there is no telling what may happen next!**

Pray

Jesus, I am Yours. What I have belongs to You. All that I am, all that I have, I give it to You. Use me, bless me, correct me, and direct me. I give You all of me. I want to be a true disciple, becoming like You in every way! Amen.

DAY 2

Settle

Stand up and take a deep breath in, hold it a moment, and then release it slowly. Do this three or four times, and as you release your breath, release your worries of the day as well! Now focus your full attention on the One who loves you unconditionally—Jesus! No matter what you've done or how you might blow it, He's ready to meet with you!

Focus

²²*Immediately Jesus made the disciples get into the boat and go on ahead of him to the other side, while he dismissed the crowd.* ²³*After he had dismissed them, he went up on a mountainside by himself to pray. Later that night, he was there alone,* ²⁴*and the boat was already a considerable distance from land, buffeted by the waves because the wind was against it.*

²⁵*Shortly before dawn Jesus went out to them, walking on the lake.* ²⁶*When the disciples saw him walking on the lake, they were terrified. "It's a ghost," they said, and cried out in fear.*

²⁷*But Jesus immediately said to them: "Take courage! It is I. Don't be afraid."*

²⁸*"Lord, if it's you," Peter replied, "tell me to come to you on the water."*

²⁹*"Come," he said.*

Then Peter got down out of the boat, walked on the water and came toward Jesus. ³⁰*But when he saw the wind, he was afraid and, beginning to sink, cried out, "Lord, save me!"*

³¹*Immediately Jesus reached out his hand and caught him. "You of little faith," he said, "why did you doubt?"*

³²*And when they climbed into the boat, the wind died down.* ³³*Then those who were in the boat worshiped him, saying, "Truly you are the Son of God."*

(Matthew 14:22-33)

¹⁰Then Simon Peter, who had a sword, drew it and struck the high priest's servant, cutting off his right ear. (The servant's name was Malchus.)

¹¹Jesus commanded Peter, "Put your sword away! Shall I not drink the cup the Father has given me?"

(John 18:10-11)

Reflect

I would hate to be known by my worst moments, wouldn't you?

There's a lady in our town whom I've had one personal interaction with—just one—and it wasn't my best moment. Every time I see her in passing now, I wonder what she's thinking. I want to say, "Hey, let's be friends. Really, I'm a nice person. I think maybe you got the wrong impression of who I am." Instead, I just smile and try to be really pleasant. But I'm afraid that first moment defined me for her.

There are several people in the Scriptures who I think have been defined by moments that probably weren't their best either. For instance, consider Thomas, one of the original Twelve. You may know him as Doubting Thomas. He got this nickname because he chose to investigate the facts of Jesus's resurrection for himself. He had questions. He wanted to see Jesus face-to-face before he believed Jesus was alive. Honestly, that sounds reasonable to me. I would have had questions too. Maybe he had doubts, but he searched for the truth until he found it. What if we called him Thomas the Investigator instead? Or Seeking Truth Thomas? Doubting Thomas seems too rough a nickname to me. So, when we run into him in heaven, let's not lead with, "Hey, are you Doubting Thomas?" Let's just call him apostle Thomas, or maybe we could just say, "Hello, Sir, so nice to meet you in person!"

I also think Martha, whose story we read last week, gets a bad rep. She's often known as the tattletale who ran to Jesus to complain about her workload. But she also ran Jesus's preferred bed-and-breakfast. She was a great hostess and a hard worker, so let's give her some credit. And perhaps in heaven we can ask her, "What was it like to have Jesus over for dinner?"

Then there is Peter, the one who, after stepping onto the water, took his eyes off Jesus (Matthew 14:29-30); the one who cut off a guard's ear in the garden of Gethsemane (John 18:10-11); and, as we'll see tomorrow, the one who denied Jesus on the night of his arrest—not once, but three times

(Luke 22:54-62)! These certainly were not Peter's best moments, but neither were they all that defined him.

With each of these messy biblical heroes, we need to look at the whole picture, not at one isolated moment when they got it wrong. (I hope that lady from my town is reading this and will give me another chance!)

Today we're going to focus on those amazing predawn moments when Jesus and Peter walked on the water together. How incredible that must have been!

Reread Matthew 14:22-29 (page 145) and answer the following questions.

When the disciples saw Jesus walking to them on the water, what did they think Jesus was? What was their reaction? (v. 26)

What did Jesus say to them, and how did Peter respond? (vv. 27-28)

What do you think the other disciples were thinking when Peter stepped over the side of the boat and walked on water?

What do you think *Peter* was thinking, for that matter?

As a fisherman, Peter must have known how rough that body of water could be. He surely knew how deep the water was. Yes, Peter knew the dangers, but he got out of that boat anyway! He asked Jesus's permission and then joined Him in the water. That's amazing!

Now look again at Matthew 14:30-33 (page 145). According to verse 30, what caused Peter to become afraid, and what did he do?

How did Jesus respond? (v. 31)

What happened when Jesus and Peter climbed into the boat? (vv. 32-33)

It's true that when the wind began to whip around him, Peter got scared. That fear caused him to take his eyes off Jesus, and then, of course, he began to sink. Like Thomas, Peter began to doubt. But again, Peter was the one who had the faith to get out of the boat. He took the first steps, and when he faltered, Jesus was there to catch him. We have to give Peter credit for stepping over the side of the boat in faith!

When have you taken a step in faith even though you were scared?

What happened?

If what's comfortable keeps us from being the people God is calling us to be, then it's a problem.

Do you regret taking the step?

As we examine this story, we see that the boat represents a place of safety. It's a place of comfort. And comfort sounds good. I like comfort. But if what's comfortable keeps us from being the people God is calling us to be, then it's a problem.

Think about what's comfortable in your life. Are there situations that might be keeping you from being the person God is calling you to be or doing what God is calling you to do? Write everything that comes to mind below.

Your metaphorical boat might be a relationship, a life situation, a habit, or an attitude that is familiar but not necessarily best for your spiritual growth. Your "boat" might relate to sexual behavior, tithing, serving, forgiveness, language, or just laziness. Often, we stay in our comfort boats because stepping over the side in faith is scary. I've known women, for instance, who stayed in abusive relationships because they were all they knew. Or people who stayed in friend groups, jobs, or bad habits simply because they were afraid that if they left them behind, God wouldn't provide something better.

Sometimes we stay in our boats because stepping over the side requires work or sacrifice. Consider the excuses people often give for not serving in the local church. The kindergarten class is too loud. The two-year-olds are too messy. The middle school students are too hard. The parking team gets too hot. The greeting team is too outgoing. You get the idea. If we look for a reason to stay in the boat, we'll find it. But the blessings are out on the water!

What if, instead of considering the cost, we leaned into the potential blessings. For instance, what if . . .

- the kindergarten class becomes an extended family;
- the two-year-olds' parents need to hear the sermon;
- the middle school students need a role model;
- a visitor's first impression is a great one, in the parking lot; or
- the person being greeted hasn't had a smile all week?

What if stepping out of the boat makes all the difference?

Jesus says to us, "Step out of your boat and come to me. Don't worry about the wind or the waves. I'm in the water, so step out and let's do something amazing."

You'll never walk on water if you don't get out of the boat!

Here's the truth: You'll never walk on water if you don't get out of the boat!

As you apply Peter's experience to your own life, ask yourself three questions:

1. What is one area of comfort God is calling me to step away from? (Review your notes from the previous page.)

2. What fears are keeping me in my boat (failure, rejection, loss, expense, and so forth)?

3. What blessings might I be forfeiting because I refuse to step out in faith?

Like Thomas and Martha, Peter didn't always get it right. But we can't look at only their isolated moments. The bigger picture is the better glimpse into who they were. And each of them was brave and faithful. Peter's faith is inspirational. He trusted Jesus enough to do the scary thing and step out of the boat. As a result, he has the distinction of being the only disciple—the only person, for that matter—to walk on the water with Jesus.

What boat is Jesus inviting you to step out of today? Take courage, my friend, and step over the side. Keep your eyes on Jesus, and if a storm blows up, reach out and take His hand!

Pray

God, forgive me when I trust in my comforts more than Your leading. Help me to know where You are calling me to go, and then please help me to have the courage to step out in faith and do it. Amen.

DAY 3

Settle

Listen to the song "God's Not Done with You" by Tauren Wells, or another song of your choice that brings you peace and carries you into the Lord's presence. As you listen, allow the words to speak to you personally. In this song are these lines:

Even when you're lost and it's hard and you're falling apart,
God's not done with you.[1]

Allow that to sink in. God is here and is working!

Focus

[14]"*If you forgive those who sin against you, your heavenly Father will forgive you.* [15]*But if you refuse to forgive others, your Father will not forgive your sins.*"
<div align="right">(Matthew 6:14-15 NLT)</div>

[21]*Then Peter came to him and asked, "Lord, how often should I forgive someone who sins against me? Seven times?"*

[22]"*No, not seven times," Jesus replied, "but seventy times seven!"*
<div align="right">(Matthew 18:21-22 NLT)</div>

[54]*Then they seized him and led him away, bringing him into the high priest's house, and Peter was following at a distance.* [55]*And when they had kindled a fire in the middle of the courtyard and sat down together, Peter sat down among them.* [56]*Then a servant girl, seeing him as he sat in the light and looking closely at him, said, "This man also was with him." *[57]*But he denied it, saying, "Woman, I do not know him." *[58]*And a little later someone else saw him and said, "You also are one of them." But Peter said, "Man, I am not." *[59]*And after an interval of about an hour still another insisted, saying, "Certainly this man also was with him, for he too is a Galilean." *[60]*But Peter said, "Man, I do not know what you are talking about." And immediately, while he was still speaking, the rooster crowed. *[61]*And the Lord turned and looked at Peter. And Peter remembered the saying of the Lord, how he had said to him, "Before the rooster crows today, you will deny me three times." *[62]*And he went out and wept bitterly.*
<div align="right">(Luke 22:54-62 ESV)</div>

¹⁵*So when they had eaten breakfast, Jesus said to Simon Peter, "Simon, son of Jonah, do you love Me more than these?"*

He said to Him, "Yes, Lord; You know that I love You."

He said to him, "Feed My lambs."

¹⁶*He said to him again a second time, "Simon, son of Jonah, do you love Me?"*

He said to Him, "Yes, Lord; You know that I love You."

He said to him, "Tend My sheep."

¹⁷*He said to him the third time, "Simon, son of Jonah, do you love Me?" Peter was grieved because He said to him the third time, "Do you love Me?"*

And he said to Him, "Lord, You know all things; You know that I love You."

Jesus said to him, "Feed My sheep."

<div align="right">(John 21:15-17 NKJV)</div>

Reflect

Most of us know the pain of having a friend betray us. We may not use the word *betray*, but when someone we love and trust abuses that trust, it is a betrayal; and usually we feel it deeply. There is an initial shock when it happens. Disbelief. When the shock dissipates, reality sets in. And the reality of betrayal by someone we love brings pain—often a lot of pain.

We may ask ourselves, *How could this happen?* We want to run to them and say, *I love you. I've been there for you. Why?* That's when the anger comes. If we're lucky, and emotionally mature enough, we move past the anger and are left with the hurt and emptiness. We question things.

What did I do?
Should I just keep my distance from people in general?
Do I really need friends at all?

I know this kind of hurt, and I'll bet you do too. I'm sorry for your pain. I hope it hasn't left you bitter and wounded. I have asked the above questions and simmered in my stew of hurt for a time. I didn't want to do it; I just didn't know how to move past it.

How we respond when someone hurts us, especially if it's on purpose, says a lot about who we are. It reveals our character and depth of faith, but

it also may reveal whether or not we have the tools to move forward. So let's think about that today. How do we move forward when friends betray us, gossip about us, or cause us intentional harm? And how do we do it in a way that honors God?

For the longest time, I thought the Christian response was just to take it on the chin and keep moving. After all, we're told to turn the other cheek. Does that mean if they hit us once, we let them hit us again? This is where wisdom is needed. We're only human, and we need to find ways to process the hurt and set appropriate boundaries to try to minimize future pain and further damage.

After doing some research on these cheeky verses (pun intended), I have come to believe that Jesus's intent was that his followers not retaliate when they are slighted. Turning the other cheek is to surrender our right to get even and leave justice in the hands of God. However, this does not always imply pacifism or that we should not protect people in harm's way. The command is that we not seek justice for ourselves. In other words, we let it go and move on. We turn the other cheek.

When have you experienced a deep hurt, even a betrayal, from someone close to you?

What emotions did you experience through this situation?

How did you respond?

What regrets, if any, do you have regarding how you handled the situation?

It's important to realize that even in your hurt you have choices. For instance:

- You could try to get even. (Definitely not the way to go.)
- You could talk trash about them to anyone who will listen. (But you can be better.)
- You could become bitter and develop a hard heart. (Which hurts you and others.)
- You could forgive them while establishing healthy boundaries. (This may be necessary.)
- You could forgive them and move on in your relationship. (Best-case scenario.)

You have choices in how you deal with hurt. You don't have to stay trapped in the places of pain and betrayal you've experienced.

You have choices in how you deal with hurt. You don't have to stay trapped in the places of pain and betrayal you've experienced. As followers of Christ, we are commanded to forgive those who hurt us. There is a promise and a warning that comes with being willing to forgive.

Reread Matthew 6:14-15 (page 151) and complete what is below:

The promise:

The warning:

As we examine Peter's life, we see that offering and receiving forgiveness is a key part of his journey with Christ.

What did Peter ask Jesus in Matthew 18:21-22 (page 151), and how did Jesus respond?

Peter boldly approached Jesus and asked Jesus how often he should forgive someone who sins against him. Surely Peter thought he was being generous with his offer to forgive someone seven times. But Jesus answered not seven times but seventy times seven. In other words, Jesus was saying there is no cap on how many times forgiveness must be offered. It is a good thing for Peter that Jesus let him know that, because it would not be long before Peter was the one in need of mercy and forgiveness.

Who has forgiven you in the past? How have you expressed your appreciation?

Specifically, how have you needed forgiveness recently from others and from God?

The toughest night of Jesus's earthly life was surely the night of his arrest. In this one night he endured false accusations, unlawful trials, and beatings. What a painful time. In our lowest moments, we need our people. But Jesus faced this night alone. His buddy and disciple, Peter, was not really there for him.

Reread Luke 22:54-62 (page 151). According to verses 54-55, where was Peter when Jesus was seized and taken to the high priest's house?

How many times did Peter deny knowing Jesus? Write his statements of denial below:

Peter may have followed as they led Jesus away, staying close in the courtyard of the high priest, but when push came to shove, he wasn't there for Jesus. Adding insult to Jesus's injuries, Peter denied even knowing who He was—not once but three times. What must that have felt like to Jesus?

In my darkest moments, there has been so much comfort in having my husband, parents, children, and a few close friends by my side. To be betrayed and alone in those moments surely would have felt unbearable.

Jesus knows betrayal. He knows loneliness. So, we can look to Him as our example for how to handle these feelings when it happens to us. Let's look first at what Jesus did *not* do.

Turn to John 21 and read the entire chapter.

Who was the first to make his way to Jesus on the shore? (v. 7)

How did Jesus receive the disciples? What were His first words to them? (vv. 9-13)

Jesus did not go around to the other disciples and gossip, saying, "Let me tell you what Peter did the night I was arrested....Can you believe that? He was one of my closest friends." Jesus did not snub Peter around the campfire. Jesus didn't turn his back on Peter. Jesus didn't cancel Peter's membership to the apostle club. Jesus did not try to hurt Peter in any way.

What do we see Jesus do instead? What did Jesus ask Peter, and how did Peter respond? (vv. 15-17)

Why do you think it is significant that Jesus asked this question three times?

Instead of condemning Peter for his betrayal, Jesus forgave Peter, and Peter was restored into a right relationship with Jesus. Jesus could see that Peter was broken, regretting how he had responded under pressure in the high priest's courtyard. So, Jesus asked Peter directly, "Do you love me?" In fact, Jesus asked this question three times, giving Peter three opportunities to affirm his love for Jesus after having denied him three times.

Jesus was direct, honest, and kind. Upon Peter's response, Jesus simply told Peter to "feed my sheep." In other words, it's time to get back to our work, Peter. And that's exactly what Peter did. As we'll see tomorrow, Peter became a powerful preacher and the leader of the early church.

There are a few takeaways I hope you receive today. First, Jesus loves you. Let that sink in. Jesus loves you! Second, God is ready to forgive you when you repent and turn back to Him. And third, God expects you to forgive those who hurt you. It's not a suggestion, friend, it's a command. So, as you pray today, ask Jesus to help you resolve any unforgiveness that may be lingering in your heart.

Peter was redeemed for a purpose. He was more than his worst moments. This gives me hope, because I've had more than a few bad moments myself. Like Peter, I want to be redeemed for a purpose. I hope you'll join me in crying out, "Please forgive me, Lord, and put me to work!"

> Jesus loves you! . . . God is ready to forgive you when you repent and turn back to Him. . . . God expects you to forgive those who hurt you.

Pray

O, Jesus, forgive me for holding on to hurts of my past. Forgive me for my sins. Please help me to forgive those who have hurt me so I may move on with a clean heart. Thank You for Your example. Help me to be more like You, Lord. I love You! Amen.

DAY 4

Settle

Make a list of all the ways you know God: Savior, Lord, Creator, Redeemer—keep going! Now go back through the list, thanking Him for each of the ways He is present to you and all the ways He loves you.

Focus

[13]*When Jesus came to the region of Caesarea Philippi, he asked his disciples, "Who do people say the Son of Man is?"*

[14]*They replied, "Some say John the Baptist; others say Elijah; and still others, Jeremiah or one of the prophets."*

[15]*"But what about you?" he asked. "Who do you say I am?"*

[16]*Simon Peter answered, "You are the Messiah, the Son of the living God."*

[17]*Jesus replied, "Blessed are you, Simon son of Jonah, for this was not revealed to you by flesh and blood, but by my Father in heaven.* [18]*And I tell you that you are Peter, and on this rock I will build my church, and the gates of Hades will not overcome it.* [19]*I will give you the keys of the kingdom of heaven; whatever you bind on earth will be bound in heaven, and whatever you loose on earth will be loosed in heaven."* [20]*Then he ordered his disciples not to tell anyone that he was the Messiah.*

(Matthew 16:13-20)

[23]*For all have sinned and fall short of the glory of God,* [24]*and all are justified freely by his grace through the redemption that came by Christ Jesus.*

(Romans 3:23-24)

Reflect

I grew up in church. Youth ministry played a vital part in shaping my spiritual development. It was at age seventeen, while on a mission trip, that I felt a call into the ministry. I was sixteen when I sensed that I might have some leadership skills that God could use. And it was at age fourteen, while on a camping trip, that a friend boldly approached me and said, "Jennifer, I'm afraid you only know about God but haven't come to know Him personally yet. You're a good person. You know the Bible, but it has to be personal."

I'd like to tell you that I threw my arms around her and thanked her for bringing this to my attention. But I sat there stunned, thinking, *How dare you! Who do you think you are? I am a good person. I'm not doing bad stuff. I go to church, even to Bible study. Isn't that what being a Christian is all about?*

The truth was, I didn't really even know what my friend meant by knowing Jesus personally. Was there more? What did she mean? I went and sat beside a creek and called out to God saying, "If there's more, show me. If I can know you personally, help me know what that means." That particular creek was crystal clear, and as I sat waiting for God to respond, to my surprise He did! I sensed Him gently saying, *I'm in the water, Jennifer. You've got to get into the flow of the water with me.* [Remember earlier this week our focus on stepping out on the water!] *Become part of me and let's go through this journey together.* I hope that doesn't sound too cheesy to you, because it's true. That's my salvation story. I said "Yes, Sir" that night. "Yes, Sir, I want to know You personally and follow You closely."

That night, beside that pretty little creek, was the beginning of my journey in Christ. I did not then, nor do I now, have it all figured out. But I was ready to trust God not only as my Savior but also as the Lord of my life. Today I'm so grateful for my friend and her courage to confront me with my own truth.

When it comes to Jesus, it's all about relationship! That's why Jesus asked his disciples two all-important questions.

When it comes to Jesus, it's all about relationship!

Reread Matthew 16:13-20. What did Jesus ask first, and how did they respond?

What was Jesus's second and more personal question? Who answered, and what did Jesus say?

Who do those closest to you say Jesus is?

Now it's your turn: Who do you say that Jesus is? And is it *personal*?

It was Simon Peter who spoke up and declared that Jesus was the Messiah, the Son of the Living God!

Read Jesus's response to Simon Peter below. Then, draw two lines beneath what Jesus promised to give Peter and what he would do as a result.

[18]*"I tell you that you are Peter, and on this rock I will build my church, and the gates of Hades will not overcome it.* [19]*I will give you the keys of the kingdom of heaven; whatever you bind on earth will be bound in heaven, and whatever you loose on earth will be loosed in heaven."* [20]*Then he ordered his disciples not to tell anyone that he was the Messiah.*

(Matthew 16:18-20)

This conversation took place in Northern Israel, at Caesarea Philippi. I've been to this location on several occasions. It's memorable and overwhelming in many ways. First, there is an enormous cave opening there. In Jesus's day it was known as *pulai hadou*, translated as "the realm of the dead" or "the gates of hell."[2] There is also a stream that flows there. It is beautiful, yet for me it still was a little ominous to behold because of its history.

In the first century, Caesarea Philippi was considered off limits to devout Jews. It was the red-light district of the day, a city filled with prostitutes and the pagan worship of Pan. Temples were erected at the mouth of the cave to appease the gods they believed would emerge from the underworld. The stream that flowed from the cave was believed to have the power of fertility. So, in the spring, all types of sexual immorality was practiced there. It was truly an evil place.

And Jesus took his disciples there. That was—and is—shocking. First, he took them to Samaria, where no respectable Jews would go, and then to the eastern side of the Galilee, where the Gentiles lived. But Caesarea Philippi

was next-level off limits. Jesus and the disciples were at the place considered to be the literal gateway to hell. The debauchery was surely revolting. The disciples must have been shocked just to be there. But Jesus had a purpose.

It was in this setting that Jesus essentially said, "Look around! Not even this, the gates of hell, will prevail against my church. And Peter, you will build that church with power and authority. Don't think for a minute that hell wins. In the end, it's all about my Father!"

What hope does Jesus's declaration in Matthew 16:18 (page 158) give you today? What are you facing, or what is the world facing, about which you need to know Jesus can and will overcome?

Jesus chose Peter, a young fisherman who proved to be a hothead at times and a coward at others. Why would Jesus use such a messy person? It's because messy people are all God has to work with. We *all* are messy people. The key to being used isn't having it all together; it's knowing Jesus personally and making yourself available.

How might you make yourself available for Jesus to use *you* in building His church?

As we've seen earlier this week, Peter had failings, but he bounced back well. In fact, as we'll see tomorrow, after his redemption Peter took on a boldness that resulted in the salvation of thousands and, just as Jesus predicted, the establishment of the family of God—the church.

Today Caesarea Philippi is a beautiful park. The first time I visited there, families sat beside the stream picnicking. Hyrax, little mountain bunnies, played on the rocks, and children splashed in the stream. It was picturesque.

God is the redeemer of messes—like Peter, like me, and like *you*, my friend!

Yet as I mentioned previously, when I glanced at the huge cave, its darkness was still ominous. Remembering what must have taken place there was, for me, like visiting the Roman Colosseum—hard to enjoy. The history is just so dark.

But as I glanced again at the families, I thought of what God can do. He can redeem anything and anyone, no matter how far gone. It's odd that of all the places I love to visit in Israel, this is among my favorites, despite its difficult history. I guess it's because what was once very messy and evil has, in fact, been redeemed. God is the redeemer of messes—like Peter, like me, and like *you*, my friend!

Pray

Read Romans 3:23-24 again and thank God for what this means to you today:

> *²³For all have sinned and fall short of the glory of God, ²⁴and all are justified freely by his grace through the redemption that came by Christ Jesus.*

If you're not sure that you have a personal relationship with God, reach out to someone who can talk with you—your Bible study leader, pastor, or a Christian mentor. (And if you want to reach out and email me at jen@harvestchurch4u.org, I'll do my best to get back with you!)

DAY 5

Settle

As you quiet your heart to be with the Lord, consider how God has been at work in your life recently. Thank Him for His presence, and ask Him to speak clearly to you about anything that may be causing a feeling of separation from Him.

Focus

Read all of Acts 1 and 2.

Then Peter stood up with the Eleven, raised his voice and addressed the crowd: "Fellow Jews and all of you who live in Jerusalem, let me explain this to you; listen carefully to what I say."

(Acts 2:14)

[22]"Fellow Israelites, listen to this: Jesus of Nazareth was a man accredited by God to you by miracles, wonders and signs, which God did among you through him, as you yourselves know. [23]This man was handed over to you by God's deliberate plan and foreknowledge; and you, with the help of wicked men, put him to death by nailing him to the cross. [24]But God raised him from the dead, freeing him from the agony of death, because it was impossible for death to keep its hold on him."

(Acts 2:22-24)

[36]"Therefore let all Israel be assured of this: God has made this Jesus, whom you crucified, both Lord and Messiah."

[37]When the people heard this, they were cut to the heart and said to Peter and the other apostles, "Brothers, what shall we do?"

[38]Peter replied, "Repent and be baptized, every one of you, in the name of Jesus Christ for the forgiveness of your sins. And you will receive the gift of the Holy Spirit. [39]The promise is for you and your children and for all who are far off—for all whom the Lord our God will call."

⁴⁰With many other words he warned them; and he pleaded with them, "Save yourselves from this corrupt generation." ⁴¹Those who accepted his message were baptized, and about three thousand were added to their number that day.

(Acts 2:36-41)

Reflect

Those in the nutritional supplement business often promote their products with before-and-after pictures. It's their way of saying, "Look, we get results!" I'm on a nutrition program now, and the first thing my coach told me was, "Take a lot of pictures today. Get every angle, so that in a few months you can see the transformation that healthy nutrition will bring." Eight months later and thirty pounds gone, she was right. The pictures told the story. There was the before and now the after. Some transformation occurred.

When I think of the apostle Peter, I think of him as a before-and-after story. There is Peter before the betrayal, Resurrection, and restoration, and there is Peter after. He loves Jesus as both versions. Both before and after the Resurrection, Peter was passionate and bold. But after his restoration experience with Jesus on the beach in Galilee, Peter developed a single-mindedness to spread the gospel.

If you didn't take time to read all of Acts 1 and 2 during the Focus part of today's lesson, I encourage you to stop now and read those chapters. There's a reason this book is called the Actions of the Apostles, or Acts for short. It is absolutely action packed. In these first two chapters Luke, the author, describes the ascension of Jesus to heaven, the coming of the Holy Spirit, and the birth of the first-century church. And mingled in with all this activity is Peter's first sermon. And what a sermon it was!

Reread Acts 2:14 (page 163). Who is Peter addressing?

What is Peter communicating in Acts 2:22-24 (page 163)? What does he want to be sure the people know?

Now reread Acts 2:36-41. Of what does he assure the people, and what does he instruct them to do?

How many were baptized that day?

Peter laid out the gospel, held people accountable for their sin, and shared how to receive salvation. The result of this first impromptu-yet-Holy-Spirit–infused message was that three thousand people stepped forward to be baptized! We are definitely not seeing cowardice or betrayal anymore in Peter. This is the after version, bold and filled with God's Spirit.

When we compare the Peter who lied to a servant girl about even knowing Jesus to this Peter who preaches in power to the masses, the transformation is obvious. He is filled with a boldness to share Christ without regard to personal cost. There is a before version and an after. And the results are miraculous!

What factors do you think contributed to Peter's transformation?

When have you acted boldly to stand for Christ and His teachings? What happened?

When have you shied away from what you felt God was calling you to do? What happened?

Okay, time for me to be transparent about my nutritional program transformation. After I sent that before picture to my coach, I went on to lose thirty pounds. That's true, but it's also true that I've gained nine of those back. It hasn't been a perfect experience. I'm back on track now to get those pounds off and maintain a healthy weight for my body. But to tell you it was a once-and-done experience wouldn't be true.

In life it's often two or three steps forward and one step back. Peter was, indeed, an emboldened, empowered version of himself after Pentecost. But he was still human. Don't get the picture that once he received the Holy Spirit, he never made a mistake or struggled to know what to do. Take a look at Acts 10, for example.

Read Acts 10. When do we see Peter hesitate in this story? What does God convince Peter of, and how?

After seeing the vision of the sheet containing all types of food, Peter heard a voice say, "Get up, Peter. Kill and eat" (v. 13). Peter's response was one of shock, saying, "Surely not, Lord!" (v. 14). Peter was wrestling with God and what he was being told. Then God spoke again, saying, "Do not call anything impure that God has made clean" (v. 15). These words went beyond dietary laws to God's plan of salvation. God was helping Peter come to see that Christ had come not only for the Jews but also for the Gentiles. Peter was still growing and learning.

It's important to note that life in Christ is a constant journey and not a one-time destination.

It's important to note that life in Christ is a constant journey and not a one-time destination. From the fishing boat where Peter first met Jesus to these epic moments of power in the early church, Peter was continually growing in faith and in his relationship with his Lord and Savior. Yet he didn't always get it right.

Like mine and yours, Peter's story is messy. But that's great news for us because we, too, make messes of our lives from time to time. God loves messy people and uses messy people. After all, as I've said before, messy people are all God's got to work with!

How might God use what you have learned through your messes to minister to others?

After the baptism of the three thousand people, Acts takes us straight into the formation of the early church. These new believers came together to form the body of Christ and got busy doing the work of the church. I love these verses and what they tell us about the atmosphere of this new family of believers.

> [42]They devoted themselves to the apostles' teaching and to fellowship, to the breaking of bread and to prayer. [43]Everyone was filled with awe at the many wonders and signs performed by the apostles. [44]All the believers were together and had everything in common. [45]They sold property and possessions to give to anyone who had need. [46]Every day they continued to meet together in the temple courts. They broke bread in their homes and ate together with glad and sincere hearts, [47]praising God and enjoying the favor of all the people. And the Lord added to their number daily those who were being saved.
>
> (Acts 2:42-47)

Describe in your own words what the shared life of these new believers was like:

You won't get it right every day; but when you mess up, you can get back on track and make it your life's mission to serve Jesus with your whole heart!

These messy people, the ones Peter accused of being guilty of the crucifixion and death of Jesus, are the pioneers, the charter members, of the family of God. And at the helm of this ship is a man named Peter, a fisherman whose life changed forever when he met God's Son after a tough night of fishing. This was a man whose life continued to change as he grew closer and closer to his best friend, his mentor, his Savior—Jesus.

For Peter, for me, and I hope for you, there is the before version of ourselves and the after. There is the version that did life without Jesus and His power, and the version that is seeking Him daily. Like me and my nutritional program, you won't get it right every day; but when you mess up, you can get back on track and make it your life's mission to serve Jesus with your whole heart!

Pray

In your time of prayer today, confess your sins before the Lord.

Thank Him for His forgiveness and ask Him to turn your messes into some type of ministry. Don't waste your hurts and mistakes. Instead, be vulnerable and allow God to use you however He may choose, just as He used Peter.

When they had brought their boats to land, they left everything and followed him.

(Luke 5:11 ESV)

How God must delight when we respond to Him _____ and

follow _____.

"Even if all fall away on account of you, I never will."

(Matthew 26:33)

³*All praise to God, the Father of our Lord Jesus Christ. It is by his great mercy that we have been born again, because God raised Jesus Christ from the dead. Now we live with great expectation, ⁴and we have a priceless inheritance—an inheritance that is kept in heaven for you, pure and undefiled, beyond the reach of change and decay. ⁵And through your faith, God is protecting you by his power until you receive this salvation, which is ready to be revealed on the last day for all to see.*

⁶*So be truly glad. There is wonderful joy ahead, even though you must endure many trials for a little while. ⁷These trials will show that your faith is genuine. It is being tested as fire tests and purifies gold—though your faith is far more precious than mere gold. So when your faith remains strong through many trials, it will bring you much praise and glory and honor on the day when Jesus Christ is revealed to the whole world."*

(1 Peter 1:3-7 NLT)

¹⁴*We will no longer be immature like children. We won't be tossed and blown about by every wind of new teaching. We will not be influenced when people try to trick us with lies so clever they sound like the truth. ¹⁵Instead, we will speak the truth in love, growing in every way more and more like Christ, who is the head of his body, the church.*

(Ephesians 4:14-15 NLT)

Video Viewer Guide: Week 5

Some people grow older without ever _____ _____.

We want to be like Peter and grow up in _____ _____ into _____.

Justification means just as if we had _____ _____.

Sanctification is _____ in faith and holiness, becoming more and more like _____.

WEEK 6

Paul

Giving Christ Our All

Acts 7; 9
Various Epistles
of Paul

Memory Verse

Therefore, if anyone is in Christ, the new creation has come: The old has gone, the new is here!

(2 Corinthians 5:17)

DAY 1

Settle

Before digging into God's Word today, thank Him for it. What a gift the Bible is to the world! Thank God for how these holy writings inspire, instruct, and inform us about who He is and how He wants us to live.

Focus

Read Acts 6 and 7.

The witnesses laid their coats at the feet of a young man named Saul.
<p style="text-align:center">(Acts 7:58b)</p>

[1]*Meanwhile, Saul was still breathing out murderous threats against the Lord's disciples. He went to the high priest* [2]*and asked him for letters to the synagogues in Damascus, so that if he found any there who belonged to the Way, whether men or women, he might take them as prisoners to Jerusalem.* [3]*As he neared Damascus on his journey, suddenly a light from heaven flashed around him.* [4]*He fell to the ground and heard a voice say to him, "Saul, Saul, why do you persecute me?"*

[5]*"Who are you, Lord?" Saul asked.*

"I am Jesus, whom you are persecuting," he replied. [6]*"Now get up and go into the city, and you will be told what you must do."*

[7]*The men traveling with Saul stood there speechless; they heard the sound but did not see anyone.* [8]*Saul got up from the ground, but when he opened his eyes he could see nothing. So they led him by the hand into Damascus.*

<p style="text-align:right">(Acts 9:1-8)</p>

Reflect

Have you ever been completely wrong about something? You sincerely believed you were right, but it turned out you were not? I'm sure there are hundreds of instances I could draw from personally, but the one that comes to mind involves a friend of mine and her misunderstanding of the word *muster*. By definition, *muster* means "to cause to gather."[1] It's often used when referring to the military. For instance, one may say, "It's time to muster the troops."

While preparing for a tough meeting one day, I said, "I've just got to muster the courage to get this done." She looked shocked and said, "What does sex have to do with this?" Now it was my turn to be shocked. I said, "What in the world are you talking about?" To which she replied, "That's what the word *muster* means, Jen. It's about sex. I learned that as a little girl."

She was serious, and I was laughing so hard I had tears rolling down my face. She said, "I've used that word that way my whole life." Still giggling, I looked up the definition of the word and showed her. She was dumbfounded, began to laugh, and said, "I seriously thought you were the crazy one. I wonder how many times I've embarrassed myself using the word *muster* in the wrong way!"

She was sincere, but she was sincerely wrong. That's happened to me before about people, theology, recipes, and so many things. At times, I have sincerely believed the wrong thing. My heart was in the right place, but my information was just wrong.

When have you been wrong? What did it take for you to admit it?

Would others say you are easily correctable? If not, why do you think that is?

We first meet Paul, also known as Saul, in Acts 7. He was a well-educated Pharisee who had trained under Gamaliel, a famous theologian of the day. He was also a Roman citizen, not a privilege many Jews shared. Paul was a known figure and leader in the community. He was sincere about his faith. And he was zealous about following God and being a faithful Jewish leader. But he missed the main thing. He missed seeing that Jesus was God's Son. In fact, he missed it so completely that he set out to eradicate the followers of Jesus completely.

Return to Acts 6 and 7 and complete the following.

Who is the first man named among those chosen to distribute food to the widows? How is he described in 6:5, 8?

Why did opposition arise against Stephen? What did this opposition do?

How would you summarize Stephen's speech in Acts 7?

What happened next? Why did they stone Stephen?

According to verse 58, who was among them?

Acts 6 gives us a picture of who Stephen was and the ministry in which he was involved. Acts 7 gives us the powerful account of the speech Stephen delivered right before becoming the first believer martyred for his belief in Christ. Stephen was stoned, and Luke's account here in Acts is clear that "the witnesses laid their coats at the feet of a young man named Saul" (v. 58). (Saul was his Hebrew name, and Paul was his Roman name. We will be using both throughout this week.)

The next time Scripture mentions Saul (again, also known as Paul), we see that he was continuing his persecution of the followers of Christ.

Summarize Acts 9:1-2 (page 173) in your own words below.

Saul's zeal took him beyond Jerusalem toward Syria where he came face-to-face with Jesus on the road to Damascus.

Recap the famous Damascus Road experience in Acts 9, telling what happens verse by verse:

Verse 3:

Verse 4:

Verse 5:

Verse 6:

Verse 7:

Verse 8:

Being struck down and blinded and then hearing a voice from heaven did the trick for Saul. (As it should have! That's a lot!) As we will see, his Damascus Road experience forever changed the direction of his life.

Spoiler alert: As passionately as Saul had persecuted believers, he now set out with that same zeal to make more of them. This was a radical change that proved to be both life and relationship altering for him. Saul, whom the Christians feared, became the greatest missionary the church has ever seen.

How does life change of that magnitude happen? In two ways:

1. a personal encounter with Jesus, and
2. humility to admit you've been wrong.

These two things were true for Paul, and they're true for us today—*if* we want real life change. Self-help books only get us so far. Real change comes from knowing Christ, admitting where we've been wrong (also known as repenting from sin), and then choosing God's truth and grace over our own understanding.

Spend a moment in prayerful reflection. Ask Jesus if there is an area of your life in which you have been wrong. If so, choose to have the humility to admit it and move in the right direction with Christ's help. Write your thoughts here:

As we travel through Paul's story, we will see the transformation from zealous persecutor of Christians to the most prolific evangelist and writer of the first-century church. When confronted with Christ Himself, Paul had the humility to admit his error and receive the truth. May we do the same!

Pray

Use the ACTS model of prayer today:

A—Adoration: Praising God for who He is.
C—Confession: Admit before Him your sins.
T—Thanksgiving: Thank Him for what He has done and is doing.
S—Supplication: Bring your requests before your heavenly Father.

> **Real change comes from knowing Christ, admitting where we've been wrong, and then choosing God's truth and grace over our own understanding.**

DAY 2

Settle

Hum or sing a familiar song to quiet your heart today. "Amazing Grace," "It Is Well with My Soul," or even "Jesus Loves Me" are some well-known quieting songs. Focusing on the words, let the melody become a prayer as you come before Jesus.

Focus

[10]In Damascus there was a disciple named Ananias. The Lord called to him in a vision, "Ananias!"

"Yes, Lord," he answered.

[11]The Lord told him, "Go to the house of Judas on Straight Street and ask for a man from Tarsus named Saul, for he is praying. [12]In a vision he has seen a man named Ananias come and place his hands on him to restore his sight."

[13]"Lord," Ananias answered, "I have heard many reports about this man and all the harm he has done to your holy people in Jerusalem. [14]And he has come here with authority from the chief priests to arrest all who call on your name."

[15]But the Lord said to Ananias, "Go! This man is my chosen instrument to proclaim my name to the Gentiles and their kings and to the people of Israel [16]I will show him how much he must suffer for my name."

[17]Then Ananias went to the house and entered it.

(Acts 9:10-17a)

So in Christ Jesus you are all children of God through faith.
(Galatians 3:26)

God decided in advance to adopt us into his own family by bringing us to himself through Jesus Christ. This is what he wanted to do, and it gave him great pleasure.
(Ephesians 1:5 NLT)

[20]I have no one else like Timothy, who genuinely cares about your welfare. [21]All the others care only for themselves and not for what matters to Jesus Christ. [22]But you

know how Timothy has proved himself. Like a son with his father, he has served with me in preaching the Good News.

(*Philippians 2:20-22 NLT*)

Meanwhile, I thought I should send Epaphroditus back to you. He is a true brother, co-worker, and fellow soldier. And he was your messenger to help me in my need.

(*Philippians 2:25 NLT*)

Read Colossians 4:10-14 for more commendations from Paul to his coworkers in ministry.

Reflect

For me, their names are Teri, Connie, Pam, Billie, Krista, Sally, Jo, Debbie, Michael, Patty, Tracey, Jill, and Tom. Other than family, these are some of the most influential encouragers and partners I've had in ministry. Without them, I probably would have given up a long time ago. In my many years of serving Christ, one of the things I've learned is that I can't do life alone. I need a community around me. Partners. People with varying gifts who love Jesus, love me, and have a shared vision of ministry. Trying to do the Lord's work in isolation is just too hard. We are meant to serve the Lord together.

Who has encouraged you and partnered with you in your spiritual journey?

Trying to do the Lord's work in isolation is just too hard. We are meant to serve the Lord together.

How can you show them your appreciation for their contributions in your life and ministry?

For Paul, their names were Ananias, Silas, John Mark, Barnabas, Onesimus, Timothy, Lydia, Phoebe, Luke, Priscilla, and Aquila. These are just some of the many names on Paul's list of coworkers in ministry. He did not do life alone.

Let's take a look at a few of these ministry partners.

Look up the following Scriptures and write anything you learn about these individuals and their connection or contribution to Paul.

Timothy—1 Timothy 1:2

Phoebe—Romans 16:1-2

Titus—Titus 1:4-5; 2 Corinthians 8:23

Onesimus—Colossians 4:7-9; Philemon 10-16

Church of Philippi—Philippians 4:15

Barnabas—Acts 9:26-28; Acts 12:25; Galatians 2:1

Ananias—Acts 9:10-19

Timothy worked alongside Paul and was like a son in the faith. Phoebe was a deacon of the church in Cenchreae and a helper to Paul. Titus was a faithful coworker of Paul. Onesimus was like a son to Paul. And here's an extra fun fact: all three were among those who delivered Paul's letters to the churches. (Phoebe delivered Paul's letter to the Romans, Titus delivered Paul's first epistle to the Corinthians, and Onesimus delivered Paul's letter to Philemon.)

When it came to financial support, the church of Philippi was there for Paul (Philippians 4:15).

Barnabas, true to his nickname "Son of Encouragement" (Acts 4:36 NLT), spoke on Paul's behalf so that the disciples would accept him (Acts 9:28).

And Ananias—well, what courage and faith Ananias had! After Paul's Damascus Road experience, God told Ananias to go and minister to Paul.

That had to be scary for him, because Paul was known for arresting and persecuting those who followed Christ. But Ananias obeyed God, and Paul was blessed through his obedience (Acts 9).

As we saw in Week 3, Elijah needed Elisha to help overcome his depression and discouragement. Peter had James and John. Paul, too, needed people. So do you and I!

I watched a special on tennis players, and one of the things that stuck out to me was how much some of them struggle emotionally and mentally. The experts seemed to attribute this to the fact that tennis is primarily a solo sport. Elite tennis players spend a great deal of time alone. On the other hand, athletes who play on a team, such as soccer or baseball, don't face quite the same struggles. When they hit a rough patch, there are others there who know them well enough to notice and help.

Christianity is meant to be lived out as a team—or as Paul says in Ephesians, as a family. One of the precious gifts God gives us when we accept Jesus as Savior is a spiritual family.

> **Look back at Ephesians 1:5 (page 178) and complete the verse below:**
>
> *God decided in advance to _____ us into his*
>
> *own _____ by bringing us to himself through*
>
> *Jesus Christ. This is what he wanted to do, and it gave him great*
>
> *_____.* **(NLT)**

> One of the precious gifts God gives us when we accept Jesus as Savior is a spiritual family.

God's plan has always been to adopt us into His family through Jesus, and don't miss this: doing so gives "him great pleasure"!

Every person—past, present, and future—is born as a precious creation of God with sacred worth. But as Galatians 3:26 tells us, we become a child of God through faith in Jesus. This is what the Scriptures mean by being born again:

> All praise to God, the Father of our Lord Jesus Christ. It is by his great
> mercy that we have been born again, because God raised Jesus Christ from
> the dead. Now we live with great expectation.
>
> (1 Peter 1:3 NLT)

We are born the first time into the human family, but when we are born again we join God's family. When you accepted Jesus as Lord, God adopted

you into His spiritual family. As a believer you have billions of brothers and sisters all around the world. And we are meant to do life alongside our spiritual family. This is important to God, evidenced by the many "one another" commands in the New Testament.

Look up each Scripture and write the "one another" command beside it:

John 13:34

Romans 12:10

Galatians 5:13

Ephesians 4:32

Ephesians 5:21

Colossians 3:13-16

Hebrews 3:13

James 5:16

The Greek word *allelon*, commonly translated as "one another," appears one hundred times in the New Testament, and about half of those instances are a direct command.[2] So, the above verses give us just eight of almost fifty "one another" commands in the New Testament! Clearly God cares about us caring for one another as sisters and brothers in Christ.

Christianity is not a solo sport. It is meant to be a team experience. We need one another for so many reasons, and others need us. Paul knew this, and his ministry was exponentially enhanced because he did not go it alone.

How does being part of a local church help us live out our faith as believers?

What are the dangers of not regularly participating in corporate worship, small groups, or team ministry/service?

In the past few years, church attendance in North America has dropped radically. Even people who say they attend regularly often show up in person only once every six to eight weeks. This is a dangerous pattern. Being part of a family means staying connected in meaningful ways on a regular basis.

I've found that if I want to keep a friendship alive and well, it requires about two hours every two weeks at a minimum. Without that regularity, it's hard to know what's going on in a person's life. If we are going to live out the "one-anothers" of Scripture with our brothers and sisters in Christ, it requires time and attention.

Paul's coworkers knew how to help him in ministry because they spent time with him and knew him personally. Their lives were lived side by side on a regular basis. They took Scripture to heart as they loved one another, cared for another, corrected one another, and prayed for one another. That kind of devotion is not carried out today only through text or email. It's best done in face-to-face relationships on a regular basis. It requires commitment, consideration, and time.

> **If we are going to live out the "one-anothers" of Scripture with our brothers and sisters in Christ, it requires time and attention.**

How do you sense God calling you to live out your faith in community in each of these areas during this season of life? Listen prayerfully, and then write your thoughts below.

Church attendance

Small group involvement

Serving in and through my local church

Developing deep friendships

Knowing and meeting the needs of other believers

What next step do you feel called to take to increase your devotion to God's family?

We need both people and purpose as God's children.

Every now and then I will get busy doing life and find myself surrounded by people yet feeling emotionally and spiritually alone. That's when I remember the example of Paul. We need one another in so many ways—not at a distance, but up close where we can know and be known. We need both people and purpose as God's children.

Can we do life alone? Yes, we could. But that is not what our heavenly Father wants for us. He wants us to participate in the family of God and enjoy life alongside our many sisters and brothers. At first it requires effort on our part, but in the long run it pays off in more ways than we can count!

Pray

- Thank God for welcoming you into His family.
- Ask Him to give you the desire and courage to fully engage in a local church.
- Confess any excuses you may have given in the past for why you've not been fully involved in His family and let Him know you want to participate more fully.

DAY 3

Settle

Get creative today as you begin this time with God. Take a walk, draw, paint, journal, sing. Do something that uses your unique gifts or abilities, and as you do it, thank God for giving you the ability to do those things!

Focus

¹I commend to you our sister Phoebe, a deacon of the church.

³Greet Priscilla and Aquila, my co-workers in Christ Jesus.

⁷Greet Andronicus and Junia, my fellow Jews who have been in prison with me. They are outstanding among the apostles, and they were in Christ before I was.

(Romans 16:1, 3, 7)

³⁴Women should remain silent in the churches. They are not allowed to speak, but must be in submission, as the law says. ³⁵If they want to inquire about something, they should ask their own husbands at home; for it is disgraceful for a woman to speak in the church.

(1 Corinthians 14:34-35)

²⁶So in Christ Jesus you are all children of God through faith, ²⁷for all of you who were baptized into Christ have clothed yourselves with Christ. ²⁸There is neither Jew nor Gentile, neither slave nor free, nor is there male and female, for you are all one in Christ Jesus. ²⁹If you belong to Christ, then you are Abraham's seed, and heirs according to the promise.

(Galatians 3:26-29)

¹¹A woman should learn in quietness and full submission. ¹²I do not permit a woman to teach or to assume authority over a man; she must be quiet. ¹³For Adam was formed first, then Eve. ¹⁴And Adam was not the one deceived; it was the woman who was deceived and became a sinner.

(1 Timothy 2:11-14)

Reflect

In high school I attended my first in-depth Bible study. The leader took us verse by verse through the Book of 1 Corinthians. When we got to chapter 14,

he read, "Women should remain silent in the churches. They are not allowed to speak, but must be in submission, as the law says. If they want to inquire about something, they should ask their own husbands at home; for it is disgraceful for a woman to speak in the church" (vv. 34-35). This young youth leader went on to almost jokingly say, "So, girls, keep your mouths shut and leave the ministry to the men." He laughed and kept going.

Honestly, I didn't know how to respond. I had questions. My heart hurt. Was that true? Was I a lesser person in God's eyes because I was a girl? It left me confused, a little angry, and mainly insecure. As a young girl who already felt a calling into ministry, what was I to do with this passage?

I just didn't know how to deal with it. After asking several people, I was more confused than ever. I read commentaries, and the responses were all over the place. As a result, for years I was not a fan of the apostle Paul. Honestly, as I read his writings about women and heard a few sermons based solely on 1 Corinthians 14 and 1 Timothy 2, I thought, *Dude, are you a jerk? What's your deal with women?*

Review 1 Corinthians 14:34-35 and 1 Timothy 2:11-14 (page 185). If all you had to go on were these verses, what would you say was Paul's view of women?

As I read passages about Jesus's interactions with women, and even Paul's own personal interactions with women, I saw that they were respectful. Jesus and Paul actually elevated the status of women in that culture. Jesus allowed Mary to sit at His feet and learn, just as the male disciples did. And Paul commended Phoebe as a deacon, Junia as an apostle, and Priscilla and Lydia as teachers. I was confused! I sincerely wanted to know what the truth of the matter was regarding women and their place in the world.

I've actually known women who walked away from the church because they felt some of the teachings toward women were too restrictive and demeaning. Or at least the material presented to them came across in that

manner. I have struggled with similar thoughts. How could Paul, the great evangelist, missionary, writer, teacher of the early church, giant of the faith, and lover of Jesus put these restrictions on women? Did I just need to embrace it, or was there more to understand here?

What questions have you had about the role of women in ministry?

How have women in ministry been a blessing in your life?

I've heard several messages on this topic and, honestly, opinions are all over the place. I'm not interested in opinions; I want to know the heart of God on the matter. So, what do we do when we find a Scripture that leaves us confused? We keep digging. We keep asking. We allow Scripture to interpret Scripture. In other words, we look at the whole of Scripture and allow it to speak into the full truth of God's character. When we come to a passage or concept of theology that is fuzzy, it is wise to turn to the passages that are clear to help us understand.

For instance, as we search the Scriptures for truth, we come across Scriptures that inform us just how vital women have been in ministry, especially in the first century.

Look up the following Scriptures and write beside them the women mentioned and what we learn about them.

Luke 2:36

Acts 21:8-9

> **What do we do when we find a Scripture that leaves us confused? We keep digging. We keep asking. We allow Scripture to interpret Scripture.**

Luke tells us that Anna was a prophet. In the Book of Acts we read about a man named Philip with four daughters who were prophets. A prophet, by the way, is someone who brings a message from God to the world.

Then in Romans 16, Paul—the guy I thought was a jerk toward women—commends Phoebe, a deacon in the church, who carried his letter to Rome. He goes on to list a myriad of women as his co-laborers.

Read Romans 16:1-15, noticing the many people Paul commends as his coworkers in Christ. List below the names of the women working alongside Paul. (You may be unsure about some of the names and that's okay. Do your best and then read on to check yourself.)

What other notable women are recorded in Scripture? List those that come to mind.

Now reread Galatians 3:26-29 (page 185). What do these verses, also written by Paul, reassure us?

In Romans 16, Paul commends ten women: Phoebe, Priscilla, Mary, Junia, Tryphanena, Tryphosa, Persis, Rufus's mother, Julia, and Nereus's sister. Ten women receive honorable mention from the apostle Paul! And in Galatians 3, Paul himself tells us that in Christ, all are one without distinctions or divisions.

Passages such as these inform my understanding as I study other passages such I Corinthians and I Timothy. Was there something more going on? Is there a cultural influence I am missing? Would the same Paul who commended women also generally condemn women in roles of leadership?

I am certainly no theologian, so for years I have turned to those who are biblical scholars for explanations. Bishop N. T. Wright, a scholar among scholars, is one of the people who has shed a great deal of light on these passages. He writes, "[Paul's] central concern in 1 Corinthians 14 is for order and decency in the church's worship. This would fit extremely well. What the passage cannot possibly mean is that women had no part in leading public worship."[3]

I write this devotional today with some anxiety, because it's a sensitive and complex issue for me. I've received my fair share of criticism over the years for being a woman in ministry. This topic is not a banner I wave with anger or a soap box I will rant upon. Instead, it has been a personal journey of figuring out if God can and wants to use the gifts that He put inside me, a woman. And it has become a quest to help other women have an easier time discerning their call into ministry.

The first time I spoke in church without my husband, Jim, beside me, was an emergency. Jim had the flu, my son, who was only two, was in the hospital with dehydration, and we were a new church with no one else to call upon. So, I called my parents to care for my family, and I stepped up and spoke out of necessity. The result—people accepted Christ that day. Now, I take no credit for that. But I was shocked. God moved through me, a woman.

It has been a long journey for me, and there is still much to learn and understand on the subject. I certainly don't have it all figured out. But I no longer regard Paul as a jerk toward women. In fact, quite the opposite.

We have to be careful and examine Scripture through Scripture to get to the heart of the matter. For me, the heart of the matter is this: God loves and uses both men and women to serve His purposes as He chooses. As for me, I just want to be found faithful by using whatever gifts the Holy Spirit has given me. I want to put a smile on God's face. I know you want to do the same!

Pray

Lord, give me a heart to know and understand Your will. Then help me submit to Your will and obey You in every way. I love You, Lord! Amen.

God loves and uses both men and women to serve His purposes as He chooses.

DAY 4

Settle

Is anything troubling you today? If so, bring it before the Lord right now. Pour out your heart, knowing that God loves you and hears you. Then, as best you can, set it aside and allow Him to speak to you in this time devoted to Him. Allow His peace to envelop you as you remember you are loved.

Focus

"In this world you will have trouble. But take heart! I have overcome the world."

(John 16:33b)

35Who shall separate us from the love of Christ? Shall tribulation, or distress, or persecution, or famine, or nakedness, or danger, or sword? . . .

37No, in all these things we are more than conquerors through him who loved us.

(Romans 8:35, 37 ESV)

23I have worked harder, been put in prison more often, been whipped times without number, and faced death again and again. 24Five different times the Jewish leaders gave me thirty-nine lashes. 25Three times I was beaten with rods. Once I was stoned. Three times I was shipwrecked. Once I spent a whole night and a day adrift at sea. 26I have traveled on many long journeys. I have faced danger from rivers and from robbers. I have faced danger from my own people, the Jews, as well as from the Gentiles. I have faced danger in the cities, in the deserts, and on the seas. And I have faced danger from men who claim to be believers but are not. 27I have worked hard and long, enduring many sleepless nights. I have been hungry and thirsty and have often gone without food. I have shivered in the cold, without enough clothing to keep me warm.

28Then, besides all this, I have the daily burden of my concern for all the churches.

(2 Corinthians 11:23b-28 NLT)

3Don't be selfish; don't try to impress others. Be humble, thinking of others as better than yourselves. 4Don't look out only for your own interests, but take an interest in others, too.

5You must have the same attitude that Christ Jesus had.

(Philippians 2:3-5 NLT)

Reflect

I love hearing from those of you who do my Bible studies! Your stories of life change are so encouraging. It's especially exciting to hear from those of you who are discovering the richness of God's Word and have begun applying the timeless truths of Scripture in your everyday life.

So many of your stories are amazing; thanks for sharing them with me! But not every story is a happy one. In all honesty, some of them are hard—really hard. Some of you have had to deal with abuse, disease, grief, divorce, betrayal, and financial loss. And often in those situations, it's easy to feel alone and completely discouraged. If those hard moments of life come in quick succession, or even at the same time, it can leave us weary and wondering, *Hey, God, do you see me? Do you care?*

Do you know someone who is going through a tough season today? How can you encourage them?

What's been one of the toughest seasons of your life? (It may be the season you are in currently.)

How did it affect your relationship with God?

One of my dear friends has had eight family members die in the past three months. Eight in three months! Yesterday, he came into my office, sank down in a chair, and said, "It's just so much right now. I keep waiting for God

to show me the lesson He has for me in all this. But I don't see it. I'm just trying to get through each day." My buddy is tired, emotionally exhausted, and spiritually weary. He has been the rock for his wife and family through all the loss, but his soul needs rest.

I can relate to that. There have been seasons of my life that were really hard. One tough situation after another happened, and it left me wondering if God had forgotten about me entirely—or if, maybe, I had done something to make Him mad. Were my tough circumstances some kind of spiritual repercussion or punishment?

How would you respond if someone asked you why bad things happen to God's people?

> **When life is hard, especially if the hard lasts a while, it's easy to turn the blame on God. But as the saying goes, "God is good all the time, and all the time, God is good."**

When life is hard, especially if the hard lasts a while, it's easy to turn the blame on God. But as the saying goes, "God is good all the time, and all the time, God is good." Why is it that we so often give God credit for that which Satan is to blame? God is not the author of evil.

Nowhere in Scripture are we promised that when we receive Jesus as our Savior we will be spared from hardships. In fact, quite the opposite.

Reread John 16:33 (page 190). What can we expect in this world? Why can we take heart?

I wish this verse said "if you have trouble," but it doesn't. It says *will*: "In this world you will have trouble."

One thing you can count on is that life on planet earth will have both ups and downs. This is a broken world. Sin broke it, and we live in that brokenness. So, what we have to do is learn to thrive even in the hardest moments of life. That isn't done with just a self-help book and a few therapy sessions, though those certainly have merit. It's done through the power of a relationship with Jesus.

If anyone knew about facing hardships, it was our messy person of the week, Paul. He chronicles his troubles in 2 Corinthians 11.

Reread 2 Corinthians 11:23b-28 (page 190) and list Paul's hardships below:

Paul was imprisoned, whipped, flogged, beaten, stoned, shipwrecked, adrift at sea, robbed, betrayed by those who said they were believers, imprisoned, made to endure sleeplessness and hunger and cold, and burdened for the churches. Yet it's this same man who wrote the most joyful, encouraging letter of the New Testament, Philippians. And he wrote it while in prison!

As we look at Paul's life, we must pay attention to the fact that he learned to live with an eternal perspective. His focus was on not only his present hardships but also the bigger picture of what God had called him to do and what God had promised for his future. Was he happy about what he had to go through? I doubt it. But did he have joy in his journey? Yes! Because joy is more than our circumstance. Joy is a choice. Joy is the result of healthy thinking, wise choices, and a life dependent on Christ.

So many people are chasing after a happy life. At first, that seems a fine goal. But if happiness is dependent on everything going your way, then it will always be fleeting because nobody can expect everything to go their way at all times. Joy, on the other hand, is a deep sense of peace and contentment. It comes from knowing that no matter what you face, God loves you and, ultimately, is in control.

Read again Romans 8:35, 37 (page 190). What promises can we claim here?

> **Joy is more than our circumstance. Joy is a choice. Joy is the result of healthy thinking, wise choices, and a life dependent on Christ.**

How does this influence our choice to have joy in all circumstances?

Making happiness the goal of your life will lead to a shallow, self-centered existence. I meet so many people who are utterly miserable because one or another area of their life did not turn out the way they had hoped. I get it. I've felt the same way at times. But, friends, we have to grow up. Sometimes life is hard, and we must put on our spiritual armor and choose joy anyway. If Paul had made happiness his primary goal, he would have given up very quickly. Instead, despite the many obstacles thrown his way, he persisted and prevailed.

Reread Philippians 2:3-5 (page 190) and describe the attitude Paul says we should and should not have, explaining what each attitude means.

Attitude we should not have:

What this means:

Attitude we should not have:

What this means:

Paul tells us that our attitude is not to be one of selfishness and self-interest, trying to get ahead of others. Instead, we are to take on the very attitude of Christ, being humble and putting others' interests ahead of our own. That's a tall order, but those are our instructions.

Read Philippians 1:12-30. In your own words, how would you summarize Paul's eternal, joyful perspective?

There's so much packed in these verses! Here's what I want to highlight for you. Paul didn't have a pity party as he recounted all he'd been through. Instead, he saw the eternal implications of what was happening in his present circumstances. His joy was not an accident. It was a choice.

Paul's friend and Jesus's half-brother, James, also gives us instructions on facing obstacles with joy.

Look up James 1:2-4. According to James, how can we consider it joy when we face trials?

Hardships offer opportunities for faith. Faith in the difficulties develops perseverance. And perseverance in Christ makes ordinary men and women mature. This is how we become like Christ. We endure—we grow up in Christ. And though we may not be happy about every circumstance, we can choose joy in the journey.

Pray

Lord, forgive me when I give up, give in, and give out too quickly. Help me to stand strong and choose joy, even in the hard seasons. May my life bring a smile to Your face, and may others see You in me as they watch how I face my struggles. I love You, Jesus. Amen.

> **Hardships offer opportunities for faith. Faith in the difficulties develops perseverance. And perseverance in Christ makes ordinary men and women mature.**

DAY 5

Settle

Spend some time talking with God about what He has been teaching you and all He has done in your life these last six weeks.

Focus

God demonstrates his own love for us in this: While we were still sinners, Christ died for us.

<div align="right">(Romans 5:8)</div>

For God knew his people in advance, and he chose them to become like his Son.

<div align="right">(Romans 8:29 NLT)</div>

¹Therefore, I urge you, brothers and sisters, in view of God's mercy, to offer your bodies as a living sacrifice, holy and pleasing to God—this is your true and proper worship. ²Do not conform to the pattern of this world, but be transformed by the renewing of your mind. Then you will be able to test and approve what God's will is—his good, pleasing and perfect will.

<div align="right">(Romans 12:1-2)</div>

⁴Love is patient, love is kind. It does not envy, it does not boast, it is not proud. ⁵It does not dishonor others, it is not self-seeking, it is not easily angered, it keeps no record of wrongs. ⁶Love does not delight in evil but rejoices with the truth. ⁷It always protects, always trusts, always hopes, always perseveres.

<div align="right">(1 Corinthians 13:4-7)</div>

Therefore, if anyone is in Christ, the new creation has come: The old has gone, the new is here!

<div align="right">(2 Corinthians 5:17)</div>

I have been crucified with Christ and I no longer live, but Christ lives in me. The life I now live in the body, I live by faith in the Son of God, who loved me and gave himself for me.

<div align="right">(Galatians 2:20)</div>

⁴Rejoice in the Lord always. I will say it again: Rejoice! ⁵Let your gentleness be evident to all. The Lord is near. ⁶Do not be anxious about anything, but in every situation, by prayer and petition, with thanksgiving, present your requests to God. ⁷And the peace of God, which transcends all understanding, will guard your hearts and your minds in Christ Jesus.

⁸Finally, brothers and sisters, whatever is true, whatever is noble, whatever is right, whatever is pure, whatever is lovely, whatever is admirable—if anything is excellent or praiseworthy—think about such things.

(Philippians 4:4-8)

Reflect

Today, our six-week journey of exploring some of the Bible's most notable messy people comes to a close. Through the lives of rival sisters like Leah and Rachel, and those with very different personalities like Martha and Mary, we've seen that God chooses to use people who don't have it all together. Through the lives of great but imperfect biblical heroes like Moses, Elijah, and Peter, we've seen that God meets people in their troubles and chooses to use them, even if they may seem unqualified. And this week we have seen that when someone encounters Jesus personally, as Saul did, a whole new future awaits!

When my husband, Jim, and I first launched the church we now serve, it was just us. Literally, it was Jim and me and our two kids. The task before us was overwhelming. And the dream wasn't just to start another church. (The South has plenty of those.) We wanted to start a community where people far from God came to know Him. We've heard it described as building a steakhouse for vegetarians—in other words, a church for people who weren't interested in church.

To our surprise, people began to come. But for the first few months, although the numbers were growing, we didn't see anyone coming to Christ as a first-time believer. We had a ministry coach at the time who told us to begin praying a very specific prayer. He said, "Ask God to send someone who is a known rascal in your community. Then pray that this person will experience radical life change in Christ and be very public about it."

So that's what we prayed. And that's what happened. Some well-known business owners who had been front-page rascals came to church, received

Life change is infectious!

Jesus, and began to live for Him. It was tremendous! They became our dear friends and immediately got busy sharing Christ with everyone they met.

As their story spread, an interesting thing happened: other people far from God in our community became curious. They saw the change and wanted to see for themselves what was going on in this new church family. In fact, it was during this season that we adopted a phrase that originated with Jesus and Philip in the New Testament: "Come and see" (John 1:38-39, 45-46 NLT).

Curious people from all over our area began to come and see. And over the course of the next few years, thousands of people continued to come and see and chose to give their lives to Jesus for the first time. The primary catalyst wasn't a particular sermon or a style of music; it was observing the change in the lives of people who once had been living far from God. Life change is infectious!

Recall those things that came to mind during your Settle time today—all the times during our study when Jesus essentially said "Come and see" and then taught you something new or did something new in your life. Make a list below and count the times and ways God has brought change within you and/or your life in the last six weeks.

Have you seen any evidence that these changes in you and/or your life have touched the lives of others in some way? If so, describe it below.

God is always at work, bringing transformation—sometimes in subtle ways, and sometimes in spectacular ways.

Our once rascally friends were living, breathing testimonies to the power of God. Their lives were a great example of the power of God to take something messy and turn it into something beautiful. Paul had a similar story. He is perhaps one of the most unlikely heroes in all of Scripture. His conversion from a murderous persecutor of Christians to one of the most influential missionaries the world has ever known is incredible.

The man who had stood giving approval at the stoning of Stephen and had sought to eradicate all who followed Jesus was radically changed once he met Jesus personally. Everything changes when the relationship with Jesus gets personal!

Everything changes when the relationship with Jesus gets personal!

Paul went on to travel through the Middle East and into Asia and Europe. He established numerous churches and discipled countless leaders along the way. His epistles are some of the most insightful and powerful letters ever written. The theology of letters such as Romans, coupled with the practical instruction of writings such as Ephesians, gave the early church—and us today—the tools with which to build our faith and character.

As we've seen this week, Paul also suffered tremendously for his faith. He was repeatedly stoned, imprisoned, flogged, and tortured. But he endured. Church tradition tells us that after appealing to appear before Caesar, Paul was eventually martyred for his faith in Rome around 64 CE.

In our Focus reading today, I included several of my favorite passages from Paul's writings. Do any of these Scriptures especially resonate with you? If so, tell why below:

Are there other passages from Paul's writings that are favorites of *yours*? Write the Scripture references below.

As we look at the overall impact of Paul's life, we can't miss that a huge part of Paul's ministry was his testimony. Like my rascally friends, Paul's life change was a visible indicator of what God had done in his heart. His life was changed forever, and the world around him noticed.

What happened for Paul, and for my friends, is meant to happen for all of us. As we've touched on previously, we all have a *before* and an *after*—who we were before Jesus entered our lives and who we are after. And the after should be an ever-growing reflection of the image of Jesus Himself.

Look back at Romans 8:29 (page 196) and complete the verse below:

"God knew his people in advance, and he chose them to _____

_____ _____ _____." (NLT)

Our goal as followers of Jesus is to become more and more like Jesus. It's not just to study his life and learn his stories but to take on his character and allow God to turn our messes into ministries. Paul—like Peter, Moses, Elijah, Mary, Martha, Leah, and Rachel—was a messy person. His life had ups and downs. But when he met Jesus face-to-face, he surrendered all and lived the rest of his life wanting to honor the One who knew him best and loved him most.

My friend, as we close out these six weeks together, know this: The One who knows you best also loves you most. His name is Jesus, and He gave His life for you! No matter what messes you have made or encountered in your life, or will make or encounter in the future, God is always standing ready with open arms to welcome you and call you His own! That may be hard

The One who knows you best also loves you most. His name is Jesus, and He gave His life for you!

to believe, but God's good like that. Take Him at His word and run hard to Him—now and forever. From one messy person to another, I believe in you!

Pray

- For the first or perhaps fiftieth time, give your whole heart to the Lord today.
- Meditate on Luke 10:27:

 "'Love the Lord your God with all your heart and with all your soul and with all your strength and with all your mind'; and, 'Love your neighbor as yourself.'"

- Tell Jesus this is your goal for all the days of your life!

Video Viewer Guide: Week 6

For all have sinned and fall short of the glory of God.
(Romans 3:23)

The question is not if you are messy; it's whether or not you're willing to give God your

_____ in order to turn your messes around.

"Pay attention to what you hear."
(Mark 4:24 ESV)

We must pay the most careful attention, therefore, to what we have heard, so that we do not drift away.
(Hebrews 2:1)

"Pay attention and always be on guard."
(Luke 17:3 AMP)

How do we pay attention?

_____ God _____ every day.

"Seek first the kingdom of God and his righteousness, and all these things will be added to you."
(Matthew 6:33 ESV)

Take a hard look in the mirror for an honest _____ of how you're living.

Surround yourself with strong believers and give a few of them permission to hold you

_____ for living righteously.

[9]Two are better than one,
 because they have a good return for their labor:
[10]If either of them falls down,
 one can help the other up.
But pity anyone who falls
 and has no one to help them up.

(Ecclesiastes 4:9-10)

As iron sharpens iron,
 so one person sharpens another.

(Proverbs 27:17)

Confess your sins to each other and pray for each other.

(James 5:16)

[19]My brothers and sisters, if one of you should wander from the truth and someone should bring that person back, [20]remember this: Whoever turns a sinner from the error of their way will save them from death and cover over a multitude of sins.

(James 5:19-20)

[15]Christ Jesus came into the world to save sinners—of whom I am the worst. [16]But for that very reason I was shown mercy so that in me, the worst of sinners, Christ Jesus might display his immense patience as an example for those who would believe in him and receive eternal life. [17]Now to the King eternal, immortal, invisible, the only God, be honor and glory for ever and ever.

(1 Timothy 1:15b-17)

Video Viewer Guide: Answers

Week 1

grateful

rejoice

Week 2

good enough

more, enough

answers

completely, immediately

criticized

critics, great things

qualified

limitations

don't want

Week 3

courage, confront

provide

recharge

powerful

legacy, faith

Week 4

priorities

desire

time, place

phone

notepad

no

people

Week 5

immediately, faithfully

growing up

every way, Christ

never sinned

growing, Jesus

Week 6

attention

Seek, first

assessment

accountable

Notes

Week 1

1. Ed Jarrett, "What Is the Meaning of Israel in the Bible?" Christianity.com, June 20, 2019, https://www .christianity.com/wiki/bible/what-is-the-meaning-of-israel-in-the-bible.html, accessed on May 15, 2024.

Week 2

1. Amanda Williams, "Who Is Yahuah In The Bible: The Ultimate Guide," January 14, 2024, www .christianwebsite.com/who-is-yahuah-in-the-bible/, accessed on May 15, 2024.

Week 5

1 "God's Not Done With You" lyrics © G650 Music, Sony/atv Cross Keys Publishing, Thankful For This Music, Pure Note Music, Be Essential Songs, Songs Of Universal Inc.
2. Maddy Rager, "What Are the Gates of Hell Jesus Talked About?" August 25, 2023, https://www .biblestudytools.com/bible-study/topical-studies/what-are-gates-of-hell-Jesus-talked-about.html, accessed on May 15, 2024.

Week 6

1. "Muster." Merriam-Webster.com Dictionary, *Merriam-Webster*, https://www.merriam-webster.com/ dictionary/muster." Accessed 14 May. 2024.
2. Peter Krol, "4 Tips for Reading the One Anothers in the Bible," https://www.logos.com/grow/min-one -anothers/, accessed on January 18, 2024.
3. N. T. Wright, "Women's Service in the Church: The Biblical Basis" (paper presented at the symposium "Men, Women and the Church," St. John's College, Durham, September 4, 2004), https://ntwrightpage .com/2016/07/12/womens-service-in-the-church-the-biblical-basis, accessed on May 14, 2024.

Continued from page 4

More from Jennifer Cowart

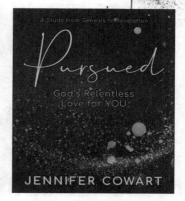

Participant Workbook
9781501863127 *print*
9781501863134 *ePub*
Leader Guide
9781501863141 *print*
9781501863158 *ePub*
DVD 9781501863165

Participant Workbook
9781501882906 *print*
9781501882913 *ePub*
Leader Guide
9781501882920 *print*
9781501882937 *ePub*
DVD 9781501882944

Participant Workbook
9781791014759 *print*
9781791014766 *ePub*
Leader Guide
9781791014773 *print*
9781791014780 *ePub*
DVD 9781791014797

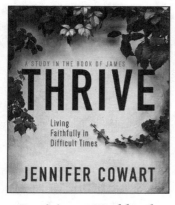

Participant Workbook
9781791027803 *print*
9781791027810 *ePub*
Leader Guide
9781791027797 *print*
9781791027797 *ePub*
DVD 9781791027766

Find other great authors and titles from

by visiting **AbingdonWomen.com**.

Looking for Streaming Video of Abingdon Women's Studies?

Check out AmplifyMedia.com.

Watch videos based on *More Messy People: Life Lessons from Imperfect Biblical Heroes* with Jennifer Cowart through Amplify Media.

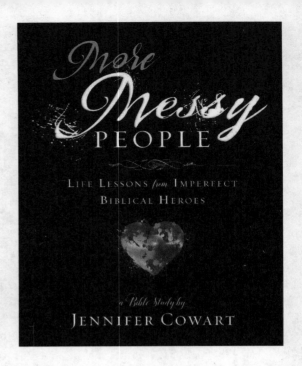

Amplify Media is a multimedia platform that delivers high-quality, searchable content with an emphasis on Wesleyan perspectives for churchwide, group, or individual use on any device at any time. In a world of sometimes overwhelming choices, Amplify gives church leaders and congregants media capabilities that are contemporary, relevant, effective, and, most important, affordable and sustainable.

With *Amplify Media* church leaders can:

- Provide a reliable source of Christian content through a Wesleyan lens for teaching, training, and inspiration in a customizable library
- Deliver their own preaching and worship content in a way the congregation knows and appreciates
- Build the church's capacity to innovate with engaging content and accessible technology
- Equip the congregation to better understand the Bible and its application
- Deepen discipleship beyond the church walls

Ask your group leader or pastor about Amplify Media and sign up today at www.AmplifyMedia.com.